Praise for Martin Gray's *Blues for Bird*

"*Blues for Bird* shows the results of thorough research in its richness of information about Parker's life and his impact on jazz. . . . Gray uses his charged words to illuminate the music, merging the terms of descent with a metaphoric allusion to Parker's personal fate. . . . Gray's epic gives us the life in full, the arc of Parker's creation and his destruction. . . . *Blues for Bird* certainly can lead us to the music it celebrates. Most of the poem's readers will probably already know the music, the words evoking it from their memories—"Koko," "Ornithology," "Scrapple from the Apple," "Cool Blues." For such readers the experience will be enriched, deepened by testimonies to its greatness and by the sufferings of the man who made it."
—WALTER CUMMINS, Editor, *The Literary Review*

"*Blues for Bird* is a good and enjoyable read, an effective distillation of some of the standard sources on Parker . . . the selection and juxtaposition of anecdote and observation has been performed with considerable skill."
—GLYN PURSGLOVE, *Poetry Salzburg Review*

"Gray effectively melds form and content throughout *Blues for Bird*. By using a heroic-narrative poetic structure, he is able to accommodate his biographical pursuits while capturing the seemingly mythic dimension of Parker's life . . . Throughout *Blues for Bird*, Gray's sense of reverence for Parker shines through this intelligent and captivating poetry. His knowledge of jazz music and this revolutionary period in American musical history is impressive. Gray has a sound sense of scholarship, and he naturally chooses his words and images with care. He has not only written a fine collection of poetry, he has added an important study to the growing body of scholarship devoted to Parker's life."
—*Journal of Canadian Poetry*

"Reading *Blues for Bird* brought back a lot of fond memories of the old days. One of the great blessings of my life was to have known and played with Charlie Parker. Martin Gray has quite a unique approach in portraying Bird's ¹⁵ . . . informative piece of reading."
—HORACE SILVER, jazz pianist

"*Blues for Bird* is one of the best books on Charlie Parker that I have ever read! Martin Gray has provided us with a brilliant in-depth look at both the man and his music."
—FRANK MORGAN, jazz saxophonist

"It was an education and extreme pleasure to have played with and listened to Charlie Parker night after night and to have witnessed some of his greatest moments. In a beautifully poetic manner, *Blues for Bird* expertly captures Parker's magnetic personality and musical genius. Well done, Mr. Gray!"
—TEDDY EDWARDS, jazz saxophonist

"A remarkable book. By the time I finished it—all along re-reading my favorite parts—I felt as though I had read a full-length biography, watched several film documentaries, and listened to dozens of Bird recordings. The images linger, burned into the reader's brain, like a sad blue sax tune playing over and over for days in one's head . . . Again, this is a high quality work, stunning to look at, an experience to read."
—*Poesy*

"The poetry is focused, full of life, and incredibly well informed . . . Charlie Parker is so real that we can breathe him in."
—*The Blindman's Rainbow*

"This is a collection that needs to be read, nay to be sung, by anyone claiming to love poetry. Make the effort to purchase, because one day *Blues for Bird* is going to be a classic."
—*Iota Poetry Quarterly*

"A monumental poetic tribute to Charlie Parker."
—*The Iconoclast*

"An effortless read, and, like any good biography, it leaves you wanting to know more, hear more, of Bird. Sent me straight back to my vinyls."
—*New Hope International Review*

"In an ever more finely shattered cubist portrait, we get angle upon angle of the man and his milieu, anecdotes and analyses of his life and his music."
—*Coal City Review*

"An excellent introduction to the life and work of Bird . . . This is a fine work that deserves a wider audience."
 —*Dead Angel*

"If you love poetry, and jazz, this is a must have."
 —*Chapbook Review*

"A very adventurous and far-reaching work that should be on the shelves of every self respecting jazz fan."
 —*On the Shelf*

"*Blues for Bird* matches Charlie Parker's virtuosity and provides many wonderful insights into the man and his music. It is a must for all Parker fans!"
 —HOWARD RUMSEY, the Lighthouse All Stars

"*Blues for Bird* contains good, solid information for both long time Parker fans and jazz neophytes alike. Martin Gray's cadence is a perfect compliment to the poetry of jazz."
 —STAN LEVEY, jazz drummer

"A truly remarkable reading experience . . . Oddly exhilarating."
 —*Jazz Notes,* The Jazz Journalists Association

"*Blues for Bird* did for me through poetry what thousands of pages couldn't do, that is convey the facts and mystery of Parker as if I were reading the beatitudes . . . The nearly 300 page narrative should be dubbed the 'Bird Bible.'"
 —*allaboutjazz.com*

"Gray drew on all available print material on Charlie Parker in constructing this surprisingly informative, detailed, long-form poem. Gray's feel for language is both elegant (he's also a leading Tennyson scholar) and hip, tumbling out in phrases that, given Parker's own sophisticated mind, one imagines would be thoroughly approved by the great man himself. Avoiding mythmaking, yet completely enthralled by Parker's genius, Gray's work transcends the sometimes suspect genre of Jazz poetry, and becomes an enjoyable worthwhile part of the literature on the saxophonist."
 —*Cadence: The Review of Jazz and Blues*

Jackson Pollock
Memories Arrested in Space

Jackson Pollock
Memories Arrested in Space

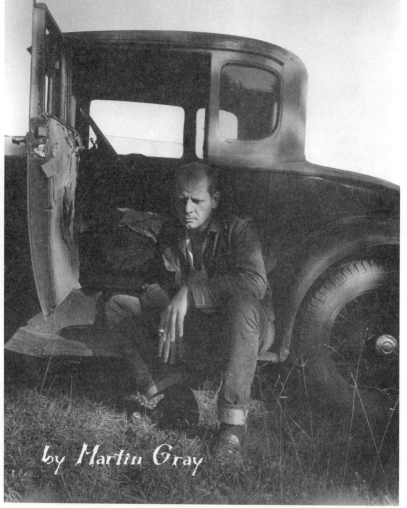

by Martin Gray

SANTA
MONICA
PRESS

Published by:
SANTA MONICA PRESS LLC
P.O. Box 1076
Santa Monica, CA 90406-1076
1-800-784-9553
www.santamonicapress.com
books@santamonicapress.com

Printed in the United States

Santa Monica Press books are available at special quantity discounts when purchased in bulk by corporations, organizations, or groups. Please call our Special Sales department at 1-800-784-9553.

Library of Congress Cataloging-in-Publication Data

Gray, James Martin.
 Jackson Pollock: memories arrested in space / by Martin Gray.
 p. cm.
 ISBN 1-891661-32-9
 1. Pollock, Jackson, 1912-1956—Poetry. 2. Abstract expressionism—Poetry. 3. Painters—Poetry. I. Title.
 PR9199.3.G752 J33 2003
 811'.54—dc22

 2003019668

Book and cover design by Lynda "Cool Dog" Jakovich

Photograph of Jackson Pollock (on the running board of his Model 'A' Ford) by Hans Namuth, copyright Hans Namuth Ltd.

Contents

Acknowledgments

Memories Arrested in Space is a verse narrative in iambic
trimeters on the life and art of Jackson Pollock
(1912–1956). There is an extensive library on Pollock
and I have used only those books and articles I consider
most significant in understanding this difficult but
very rewarding artist.

No Pollock student should avoid the comprehen-
sive biography of the painter by Steven Naifeh and
Gregory White Smith (1989). It has everything you
could wish for and more. The best illustrated account
of Pollock's art and life is Ellen Landau's *Jackson Pollock*
(1989, 2nd ed.). Besides spectacular illustrations of all
the major Pollock canvases, the book also contains
many paintings that show Pollock's development as
an abstract expressionist. As Landau has thoroughly
researched Lee Krasner's life and art as well, this
ensures the view of Pollock is a balanced one. Note-
worthy too is Elizabeth Frank's *Pollock* in the Abbeville
Modern Masters Series, which also supplies a com-
prehensive account of Pollock's artistic persona and
his development.

Three books on the artist that I rate equally for
style and understanding of Jackson Pollock's complex
personality and character are B. H. Friedman's *Jackson
Pollock, Energy Made Visible* (1972, 1995), Jeffrey Potter's
*To a Violent Grave, an Oral Biography of Jackson Pollock
(1985, 1987)* and Deborah Solomon's *Jackson Pollock, a*

Biography (1987, 2001). Friedman and Potter were friends of Pollock, and Solomon interviewed two hundred people who knew the artist. I am indebted to all three books for insights, sayings, judgments, anecdotes, and estimates that place the artist in a contemporary context.

David Anfam's *Abstract Expressionism* in the World of Art series (1990) provides a comprehensively brilliant view of that art movement. Then Thomas Crow and Michael Fried supply in "Pollock: Two Views" in *Artforum* (April 1999) a stimulating assessment of what he achieved in art. Helen A. Harrison's editing of a collection of estimates and judgments *Such Desperate Joy, Imagining Jackson Pollock* (2000) shows appreciation of Pollock growing from year to year, and Richard P. Taylor's article "Order in Pollock's Chaos" in the December 2002 edition of *Scientific American* enables us to understand the profundity behind Jackson Pollock's mature art and a way to measure how it develops during his best years.

For help of many kinds I would thank: Wayne Blizard, Phyllis Cameron, Alan Catlin, Dave Cunliffe, Stan and Dianne Evans, Peter and Jana Enman, Ruth Fraser, John Francis Haines, Martin Holroyd, Paul and Linda Jung, Tim Lander, Bill Majorki, Anne Marshall, Joe Motuz, William Oxley, Glyn Pursglove, Arthur and Holly Rowland, Guy Russell, Fred and Mary Anne Sandemeyer, Alan Schroeder, Don Schurman, Keith Shearer, Fergus Sidwell, Sam Smith, Hassan Sunderani, Nick Vincelli, and Phil Wagner.

I record a special thanks to Peter Namuth for allowing republication of one of his father's historic

photographs of Pollock; to Geoffrey Hargreaves for demanding clear logic and no redundancy in everything I write; to Liz Walther for her generosity in giving me a computer to get this job done; to Walter Nash for defining the characteristic strengths of the trimeter (in *Heliotrope* 2, 1998); and to Ed Harris for doing such a convincing job in direction and in acting the part of Pollock in the movie *Jackson Pollock*. Jeffrey Goldman could not have been more helpful as publisher.

—*Martin Gray*
Victoria, British Columbia
October 2003

Introduction

I use a form of trimeter to tell the story of Jackson Pollock's life and the development of his art. In 1997 and 2001 I used the same meter to narrate the lives and artistic endeavors of two other remarkable characters, the painter and sculptor Amedeo Modigliani (1884–1920) and the saxophonist composer Charlie Parker (1920–1955). In each case all my sources were from books, which I treat with scholarly objectivity. I follow a principle evident in some very old forms of narrative—for instance, the Icelandic family sagas—that as storyteller I am free to report what people do, what they say, and what others do and say about them, but never to presume to know what, behind the evidences of action and speech, they are feeling or thinking. The author as psychologist, as novelistic intruder, is debarred from this spare species of narrative.

The exclusion of the subjective commentator has a particular and striking consequence: that "imagery," figurative textures, symbolism, the decorative apparatus regarded by seminar students as indispensable to poetry, are virtually absent from my text. An image is the writer's attempt to explain his subject, or to explain himself in relation to his subject. My steady purpose is to oblige the subject to speak for itself, effacing my own presence, leaving interpretations to the reader. *Memories Arrested in Space* is not without metaphors, but they are the common, faded metaphors of ordinary

speech; they are not figures upon which anything significant hinges; attention is never misdirected to my fluency while the reader is properly intent on the flow of the narrative.

It is the sustained meter and its fluctuations of rhythm that carry the poem and compel the reader's attention, and eventually his assent. The defining measure is a free form of trimeter—a line of three beats, basically iambic (or implying an iambic norm), but permitting the intrusion of other types of foot with much variation in the number and placing of unstressed syllables around the central three-beat shape. A tone of voice emerges, or rather, a gradation of tones of voice; at times the tone is almost casual, like the impromptu phrasings of conversation. Sometimes the tone is of quasi-formal address and anything but conversational.

I am often obliged, for fear of muddying the rhythm, to omit the small indices of syntax, the conjunctions, pronouns, the auxiliaries, even, that marshal sentences in prose.

Readers meeting the poem for the first time may be disappointed, or frustrated, or even resentful, because this writing defies common expectations of poetry as something multi-layered and elaborately textured. It is not that; it is simple, spare, seemingly a little naive; and yet prosodically subtle and ultimately compelling, the beat driving the reader on, insistently or implicitly, to the tragic-heroic close of the story.

As far as narrative structure is concerned, seven of the books (Books II to VIII) follow chronologically from Pollock's birth to his death. Book I gives a synoptic

view of how Pollock, encouraged by Peggy Guggenheim's mural commission, went on to achieve international recognition and influence and helped to establish New York's leadership in modern art.

For those who say that the trimeter is too prosaic for extended narrative poetry, they should bear in mind what Octavio Paz says regarding the *mutual* strengths of poetry and prose: "I have written prose and poems in prose—the contamination of genres is healthy. Poetry is always missing a good dose of prose; the efficacy of a poem can be measured by the quantity of prose that it can assimilate without losing its nature. And the reverse is also true: good prose should have a dose of poetry." As a meter, trimeter demands great flexibility and constant experimentation, and that is why I have used this old but novel form in my verse biographies.

—*Martin Gray*

"Good and evil lie close together.
Seek no artistic unity in character."
—Acton

"The painter's intellect dissolves the existence
of objects and lends them a new unity;
he renders the intelligible sensible."
—Henri Bergson

"A complete picture is never a coherent one."
—Elisabeth Bronfen

Book I

Pollock Breaks the Ice

I

In 1942
Pollock had no name
but Peggy Guggenheim
had heard him spoken of
as someone promising,
deserving her support,
her patronage if men
who'd made their mark in art
would ratify her choice.

II

Stenographic Figure
was the first of Pollock's work
that Peggy put on show
in her new gallery.
She called it "dreadful" work.
One judge was Mondrian,
the founder of de Stijl.
He stood where it was hung
as if transfixed by it.
"That isn't painting, is it?"

asked Peggy Guggenheim.
Stunned by what he saw,
Mondrian kept quiet.
A lifelong Calvinist
he weighted every word
with seventy years of life.
Becoming querulous
Peggy said again,
"This man has grave defects.
Is painting one of them?
He has no discipline."
Piet Mondrian replied
"Don't be so sure of that!
But try to understand
what here is taking place.
I think this piece the most
exciting work I've seen
in all America.
This is a man to watch!"

III

Peggy, shocked, complained,
"You can't be serious.
You can't compare this work
with what you paint yourself."
Piet Mondrian replied,
"The way I paint a scene
and how I think of it
are very different things."
Silently he thought

this composition was
graffiti-scored, a mess.
When Jackson Pollock heard
what Mondrian had said
to Peggy Guggenheim
about his latest work,
like a kid he spread the word
till everyone had heard.

IV

Marcel Duchamp had shown
iconoclastic skill
when he took a urinal
and by inverting it
he turned it into "art."
Called "fountain" by Duchamp
and "R. Mutt's urinal,"
it was a readymade,
perhaps the very first.
When Peggy asked Duchamp
his honest estimate
of Jackson Pollock's work
the master said "Pas mal"
for Duchamp knew that "Yes"
is a simple thing to say
and leaves you free while "No"
is far more difficult,
obliging you to give
strict reasons for your choice.

V

This verdict of Duchamp's
came after Jack had ripped
the master's poster up
which advertised the show
and rolled it in a ball
saying with a snarl
"You know where *this* can go."
After such insolence
how Duchamp could approve
of anything Jack did
remains a mystery.

VI

So Peggy Guggenheim
commissioned Jack to paint
a work of mural art
near twenty feet by eight
to fill her entry hall.
Uncertain what to do
and how to fill that space,
Jack spent the next six months
just contemplating it
and brooding on its blankness.
He then began to paint
with bold calligraphy.
Starting as night fell
he painted fifteen hours
until the job was done.
The content he had based

on what he'd seen himself
some seventeen years before
upon a broad plateau
near Fredonia
in Arizona state.
He'd watched in shock, while men
had ambushed cayuses,
had shot them down as they
approached a draw to drink
just as the sun came up.
The slaughter of that herd
had stalked him ever since.

VII

"When I began to work
among these images,
no sooner traced their shapes
than they began to twist,
transforming into steers
and steers soon turned to bulls
and then each animal
that graced the western range—
cows horses buffalo—
stampeding far and wide
across the frenzied plain.
Upon this desert flat
I laid my floating lines.
They multiplied themselves
in raspberry yellow teal.
Realistic images

collapsed in fragments, till
no trace of them remained,
just furious energy
forever under wraps,
beyond all scrutiny."

VIII

When the mural was complete
Jack transported it
to Peggy's arty pad
on East and Sixty-First
but when they reached her place
it would not fit her wall
too long by a foot.
Eight inches from one end
had to be removed,
Duchamp deciding where
then executing this
as Jackson was by now
far too gone in drink.

IX

With a party underway
to mark the mural's end,
its installation in
the hall of Guggenheim,
Jackson bustled in,
traversed the crowded room
where guests were waiting for
the artist to appear

and at the fireplace he
unzipped his pants and peed
into the fireplace nook.
His later comment was:
"Outdoors it's natural.
In someone's fireplace it's
saying things." He'd shown
just how he'd felt that day:
"I piss upon the world."

X

Jean Helion complained
that Jackson's mural was
too repetitious in
the way it filled out space
just going on and on
because it did not have
a start or end to it.
He meant no compliment,
but Jackson felt it was
the finest compliment
that his art received.
"Cosmic" is the word
that one could use for this.
When Clement Greenberg spoke
on Pollock's newest work
made for Guggenheim
he did not stint his praise:
"I took one look at it.
Now *that's* great art I thought."

XI

Four years after this
with Jackson married to
Lee Krasner and the two
now resident in Springs
up on Long Island Sound
on one brief winter day
of introspective light,
his hands so numb with cold
he puffed on cigarettes
to lend them warmth and strength
Jackson Pollock changed
the course of Western art.
How was this feat attained?
At this time Jackson learnt
to pour his canvases,
adjusting his new need
to what he wished to say.
In his left hand he held
a half-full can of paint
and then he tilted it.
The thinned paint trickled out
like honey from the can
while in his other hand
was a hardened brush or stick
he'd used to mix the paint
by adding turpentine.
In the can he dipped the stick
then waved it canvas-bound
but just above its plane
(Matta taught him this).

"Memories arrested in space"
was the name he gave this means
and "energy and motion"
were then "made visible."

XII

To make a canvas work
by dripping paint on it
he'd need to concentrate
and master new techniques.
He gave up alcohol,
his staple for so long.
(He'd used it to relax
and hide away from *angst*).
His doctor and his friends
helped with sympathy
and by talking problems out.

XIII

From 1947
to 1951
Jackson Pollock's art
achieved its highest peak:
in 1947
seventeen works were poured,
the next year almost twice
as thirty-two were formed
and in the following year
he finished forty works

but 1950 was
the greatest year of all
no less than fifty-five
with three the largest now
each thought a masterpiece:
One and *Lavender Mist*
and *Autumn Rhythm* were
strong public favorites.

XIV

First *Tondo* ('48)
small yet exquisite
just under two foot round
in its diameter
then happy *Summertime*
completed the same year
and also his *1A*
perhaps the subtlest work
that Pollock had achieved
and then in '49
Pollock's *Number 1*.
1950 sees
Lavender Mist and *One*
and *Number 32*.

XV

In *Tondo* ('48)
Jackson's canvas is
something circular

too whole to divide
in form a living cell
with looping tracery
which comes back from the side
upon itself to make
an in-turned unity
which at its vortex turns
or else it spins, attains
a field's totality
and has no bounds within,
a cell containing worlds
and an unboundedness,
a small infinity.

XVI

In Betty Parson's words
describing what she saw
when Jackson trickled paint:
"I watched him as he worked
and like a dancer he
had canvas on the floor,
around him cans of paint.
In all of these were sticks
which he would seize and swish
and swish and swish again
with such a subtle rhythm
to all his liveliness.
His compositions were
so complex yet he stayed
in balance all the time.

Meyer Shapiro says
of painters who are great
that something happens when
they get lost while painting
and then a something else
takes over from their mind.
When Jackson lost himself
the deep unconscious came
exerting its control
and that is marvelous."

XVII

Confront the banner of
Pollock's *Summertime*
(a work of '48)
long shown at the Tate.
Some say it's simple but
its colored interplay
is subtler than we think,
some eighteen feet in length
and two feet nine in height
constructed as a frieze
and like most classic works
this panel does not flow
but turns back on itself
so that its vital rhythm
cannot have a start
nor can it reach an end.
It is continuous
endlessly in motion,

a sheer mobility.
It is as free in space
as if it were a bird
and freedom its sole hope
for flight that's effortless.

XVIII

The colors Jackson used—
red yellow ochre blue—
were put on with a brush
within those larger skeins—
the picture's armature—
of black and grey poured on
against an open ground
edaphic in its weight
and counterpoise to tease
the restless intellect.
Red yellow ochre blue—
the three primes positive—
and ochre—almost buff—
a pastel hue in feel
presents a formal ground
where landscape is invoked.

XIX

Their measured dance across
the surface of the frieze
is directional,
something that he'd learned

from three old masters there,
the great Venetians:
Titian, Tintoretto and
Tiepolo who framed
a living drama in
their fine discovery
that light and color can
be used to *balance* forms
and thus to guide our sight
along a certain path;
but Jackson Pollock grounds
his floating painting through
flecks and blebs of buff
(or ochre if you like)
along the painting's base
which grounds the swirls and rounds
and gives them gravity—
a kind of pedestal.

XX

Interstices are filled
with bleblike interest
done in buff or blue
buff bottom and blue up
where only "sky" can be
to give an ordering
a touch of the familiar
so that we recognize
by subtle visual clues
abstraction that is ours,

a celebration of
all things natural
and seasonal for us,
the round year at its height
all centered on the sun.

XXI

One day children ran
through his studio
across wet canvases
shocking their moms and dads,
but Jackson thought it fun.
Their footprints they had left
became a central part
of the structure he had made.

XXII

Number 1A ('48)
is one where every bone
and muscle that he had
is used to make his work
profoundly physical.
The human effort shows.
Jackson Pollock's plot
near seven feet by nine
engulfing everyone
who seeks to look at it.
Mercedes Matter said
that she was privileged

to see him painting this
when he suddenly bent down
and then "caressed" his work
his handprints painted in
to make it wholly his.

XXIII

That same year it appeared
in Venice's great show
the Biennale fair
Pollock's painter friend
Nick Carone went
and this is what he saw.
De Kooning's filled a wall
and Morandi, a tall man
in height was six foot three
like a monk with greying hair
combed forward on his brow
in the center of the room
studied de Kooning's work.
"These art Americans
are very interesting.
They dive into the sea
before they learn to swim"
then studied Gorky's work,
"un po' sordo" said
or "he's a little deaf.
The colors all are nice
but they're not *true* accords
and somewhat French as well."

Then through an opening
a massive Pollock stood
and it confronted him
dramatic in itself,
Number 1A ('48).
Morandi gasps "Ah...ah...
This painting is so new.
How superb it is.
Such vitality,
such radiant energy."
"It meant so much to me"
Carone said at this.
as he was witnessing
Morandi's strong response.

XXIV

The same year it was shown
Alfred Barr wrote this:
"It is a *luna park*
full of fireworks and
surprises and delights.
An energetic maze,
adventures for the eyes.
It is rotational.
Its texture seems alive."

XXV

Pollock once declared
"The floor is right for me...

I got to move around
on the outside so I'm free.
Then I'm free inside...
which frees the force which makes
the work." That was all he said,
laconic at all times
and inarticulate,
but he had stated here
a quintessential truth.

XXVI

"When I am *in* my work
I can't say what I do.
I have to 'get acquainted.'
I have no fear of change.
I know a painting has
a strange life of its own.
If I lose touch with it
the painting is a mess.
Otherwise I know
it is pure harmony,
an easy give-and-take
and the painting comes out well."

XXVII

In November '49
at the Parsons Gallery
with Pollock's work on show
Willem de Kooning said
"Look around. These are

the big shots. Jackson has
finally *broken the ice.*"
Pollock had indeed
broken through the ice
of mass indifference
and art itself if fresh
had popular appeal.
Pollock's abstract art
was recognized as *news.*
Hadn't *Time* itself
newly featured him
and recognized that fact?
Of a total twenty-seven
some eighteen paintings sold
most in the opening week
and many on first night.
Now Pollock was a name,
a name to reckon with.

XXVIII

Jackson Pollock made
a painting titled *One*.
spare yet opulent
intricate yet plain
inherent yet unique
apparent and yet real
this painting floats in space
huge yet minuscule,
provocatively calm
anxious yet serene,

a live organic thing
a form which stimulates
the human mind to dream
and organize a whole,
our part of nature that
is one fine synthesis
as rocks seas clouds trees flowers
and the mind of man himself,
atonement Pollock-style.

XXIX

Jackson followed *One*
with *Number 32*
in black enamel with
its backdrop canvas-brown.
"When his powers were at their height
Pollock did with line
everything he wished,
creating this great work
from nothing more secure
than lines of naked black.
No color there, no form
just the line alone.
He hurled himself at it
near nine by fifteen feet.
Pollock took the line
and first he tapered it
to one fine filigree
or thickened it until
it was as dense as mud.

He made it tauten up.
He made it slacken too
and halt plunge soar race fly
inventing inch by inch
a new terrain for art
with subtlest nuances."
Thus Solomon described
this vivid piece of art
now kept in Düsseldorf.

XXX

In his *Lavender Mist*
a paradox was born
where accident became
control or control accident
and there emerged the thing
that gives his later work
unique identity—
a surface flatness taut
with tension. It became
a public favorite
for it addressed itself
to focused sight alone.
Its pinkish-silver mist
and regal purplish grace
is sheerly *visual*
in spreading opulence.
Critics likened it
to the lilied glow
in Monet's Giverny.

Book II

Birth, Childhood, Adolescence

I

Some claim that birth itself
the trauma that we face
when entering this world
remains with each of us
and tempers every thought,
exerting influence
on everything we are.
Birth seals us from the start
in blessing or in curse.

II

An infant finds its breath
the moment it is born
and if there is delay
that gap is dangerous,
fatal if prolonged.
A briefer pause before
the infant draws its breath
may lead to slighter hurt.

If the emerging mind
is stunted by a lack
of vital oxygen
its ordered labyrinth
becomes a tangled maze.

III

The breath too long delayed,
autism snaps synapses
and leads to a mental death—
no hearing, speech or sight,
no recognition of
a mother, father, friend,
one's history a void
without community
and mated destiny.
All substance is left blank,
blank and featureless
and barely animal.

IV

Unable to draw breath
until the doctor cut
the cord that strangled him,
the baby Pollock's skin
was deeply cyanosed:
"black as a stove" at birth
his distraught mother said
who thought her son stillborn.

The doctor stooped and held
aloft his flaccid form
to slap some life in it.
After the first few slaps
the child was silent but
at last he gasped and cried.
Thus Jackson Pollock lived.
His ordeal had begun.
Asperger's took its toll.

V

When Stella Pollock heard
that Jack would be her last—
more would endanger her
(both mother and her child)—
initially dismayed
at birthing only sons
and longing for a girl—
one girl was all she'd need
to serve as complement,
a wholesome balance for
the four strong Pollock boys—
the only chance she had
to alter nature's flaw
was raising her last son
as if he were a girl.
Her naive attitude
had graver consequence
than first seemed possible.
Jack's sense of gender was

unduly compromised.
Throughout his life he had
skewed feelings when it came
to choice of mate and sex,
bisexual in desire
yet often impotent,
a man no world could fit.

VI

So Stella raised her son
as if he were a girl.
Till well past three he wore
fine petticoats and lace
as if each dress he donned
would make him feminine.
In toilet training too
Stella's law was harsh
insisting that he peed
as girls did, squatting down.

VII

Habits last a lifetime.
To loose his bladder Jack
would often seat himself
(so Ruth, his mistress, said)
but had alternatives.
He'd make a macho splash
at shows and openings
as ladies clad in gowns,

tuxedoed men in tow
sought to hold the press
just when his work was shown.
Unzipping quick, he'd pee
in hearth or potted plant
to stamp his mark on things
at these art gatherings
determined to become
Exhibit Number One.

VIII

When he was ten months old
an infant at the breast
young Jackson had to leave
the town where he was born—
Wyoming's Cody—for
far California
and then a Tempe farm
in Arizona heat.
Father, mother, sons
traversed five thousand miles,
criss-crossing eight large states
with two stops on the way.
American restlessness
was coursing through their blood.

IX

And Stella, household head,
insisted they move on

eight times in twelve years
because she had a dream
the grass was greener on
the fence's other side
and sought out novelty,
a modish way of life
and so the children saw
a single yearly round
and then they shifted home
to less attractive ground—
to mountain gloom, sad heights
or arid desert flats
whose soil was alkaline
then squalid urban sprawl.
So many challenges
broke Jackson's father, Roy,
whose heart was fever-strained
at the time his youngest son
had come into the world.

X

Stella's name was apt.
She was the star who shone
on all who gazed on her,
especially her sons.
She would not fault her sons
and seldom punished them.
A model mother with
hands endlessly at work
to serve her family:

pumping water from the well,
drawing butter from the churn,
kneading bread and baking loaves,
pouring candles, canning fruit,
a seamstress making clothes—
shirts, curtains, crocheting
bolsters pillows spreads
cushions tablecloths.
So fond she was of work
she'd cook for family
washing all their clothes
and sew and clean for them
through food controlling all
with fragrant pies, rich stews,
an archetypal mom
who held the navel string
to keep her sons in check.
They grew up fearful men
and served her all their lives,
each son clinging fast
in inner servitude.

XI

Orphaned early on
and from the first unloved
sent into foster care,
Roy Pollock was brought up
as a farm hand in the fields
with little feeling for
affection and its bonds,

so when his sons were small
he set unbending rules.
All worth was strictly earned
and discipline was tight
for Roy's rambunctious boys.
No one could wear jeans
("the kind without the bib")
until he had reached five,
nor fire a gun till nine
or drive a team till ten.
When working in the fields
each kept seniority
his rank and standing shown
by the implements he held:
Roy first with the horse,
Charles next with the plow,
Frank with the hoe was third,
and spades for Sande, Jay.
Jackson tagged behind,
the baby of the group
without the dignity
of any implement.

XII

Roy's eldest son was Charles,
exempted from most chores,
a senior's privilege
for Charles could read a book
just as his father could,
knew how to fire a gun

and bring down game with it,
blew bubbles and chewed gum,
could whistle a bright tune,
had a pony of his own—
he named his pinto "Prince"—
possessed mobility
to go off when he liked
in independent life.
But the greatest gift of all
Charles had artistic skill.
As would-be artist, Jack
envied his brother's gift.

XIII

Roy's second son was Jay
an athlete from the start
he was a pugilist,
licked anyone his weight
and known as "Punk" and "Squirt"
once scrapping with eight boys
until the blood had flowed
and when the bout was stopped
Jay protested loud
it should continue till
he'd vanquish everyone.
On the football field he played
halfback committedly:
"I was in on every play"
so was everywhere at once.

XIV

Frank was the middle child,
his father's favorite,
resembling his parent in
both looks and interests,
the varied skills he had
forever practical
and useful with his hands.
He liked all growing things—
a gardener who made
rose-growing his career—
and quite resentful of
his mother's dominance,
her constant moving on
in hope of better things.
"I hated it" he said.
"You'd make a bunch of friends
and then you had to leave.
It wasn't good for me.
It was no better for
Charles, Sande, Jay and Jack.
We constantly forgot
what we had learned at school.
There was no chance to grow
and no consistency."
Frank resented Jack's
freedom from all chores.
"We did the work and if
there was playing to be done
Jack was the one who played.
He fed a chick or two

an easy thing to do
or maybe gathered eggs
but never milked a cow
or split wood as I did."

XV

Sandford, Roy's fourth son
("Sande" called for short)
was close in age to Jack,
but rash and mischievous.
In adolescence he
was cowboy in his style,
his fashion of revolt
(and Jack would copy this),
and skilled in sketching like
his older brother, Charles.
He did not nurture this
because he lacked the drive
that his brother, Jackson, had
all centered on his art.
So Sande's lesser role
which Stella had assigned
was in protecting Jack.
He'd rescue him from scrapes
when too obstreperous
and when he drank too much
which often was the case
he'd put his sib to bed.

XVI

And Jackson, last not least,
the biggest Pollock son
in name and in physique,
who lacked self-confidence
in some way undefined
was anti-social and
would overcompensate
through many macho acts
but knew no tenderness,
denied this by his mom
(she never showed him love),
rejected by his dad
who thought him just a bum,
not good for anything,
at war within himself
in self-love, self-abuse,
no *savoir-faire* at all,
he moved from gaffe to gaffe
but out of this *melange*
emerged an artistry
through willed experiment
and brilliant abstract art
that took the world by storm.

XVII

Gyp was the Pollock dog
part collie, part bulldog
and wholly terrier.
He'd kill another dog

if it ventured on his patch.
When the two dogs fought
Roy used a pitchfork to
pry the dogs apart
in case Gyp turned on him
so keen he was to rule
his canine territory.
Patchwork was their cat
and when they milked a cow
the boys would squirt a stream
directly from the teat
into her open mouth.

XVIII

Conversing with a friend
a year before she died
Stella Pollock said
that when her youngest son
was only four years old
she had questioned him
on what he'd like to be
when he became a man.
Jackson had replied,
"To be an artist like
my eldest brother, Charles."
Later that same year
when he was nearly five
he had an accident
that almost put an end

to his ambitious dream
of drawing well like Charles.

XX

One morning in the yard
as Jackson held an ax
to cut a stick in two
his friend, Charles Porter, said
"Jack, you're far too young
to cut things with an ax.
Where do you want to cut?"
Putting down his hand
right index to the fore
upon the chopping block,
Jack said "Cut it just there!"
Then Porter raised the ax:
"I did not have control"
Porter later said.
The blade in striking caught
Jack's index finger just
above the final joint.
Dropping on the ground
the tip then disappeared
where the Pollock rooster pecked.
Thereafter Jackson hid
his mutilated hand,
was sensitive of it.
As an artist whose right hand
was shortened by an ax
if only just the tip

he hid this slight defect
when he was photographed,
and when he put his prints
on a painting he had done
he filled his fingertip
so no one saw his flaw.

XX

A trauma he recalled
when he was hypnotized
three years before his death
hit young Jackson when
a few weeks following
the loss of his fingertip
he had another shock:
"I sat beside my mom
when traveling to town
(Phoenix was our goal)
to sell fresh vegetables.
A bull burst from its field
and rushed toward our cart.
A man upon a horse,
a farming neighbor came
and tried to intervene
but when the bull got close
our horse shied from its shafts.
Our cart was overturned.
My mother and myself
were thrown upon the ground.
On looking up I saw

my mother lying there.
My eyes filled up with tears
and then the man approached.
Dismounting rapidly
he seized me with his hand
and with his other arm
he hit me, slapping hard.
'Why are you *crying* there?
Boys are not meant *to cry!*'"

XXII

Jack's parents never smacked
and Jack was "mama's boy"
so corporal punishment
and by a stranger's hand
while shaken up by shock
was lodged as nightmares are
and then was permanent.

XXII

Roy tried to make strong men
of his overmothered sons.
Jackson seldom talked
of his dad or family.
There was emphasis
on men and manliness.
"If you have boys you've men"
was Roy's philosophy,
so whenever it came time

to castrate calves and pigs
Roy ensured his boys
participated fully in
the annual neutering,
the oldest helping and
the youngest watching as
Roy fattened up his stock
by castrating them.
"It was a gory mess
and they squealed like crazy," said
Charles recalling this.
"I could not understand
how Dad would bring himself
to carry out this thing
and have his sons join in."

XXIII

Roy Pollock loved his farm
and loved his animals.
They all gave better yields
than any neighbors' did.
At first he'd prospered but
eventually he failed
as produce markets changed
and all was auctioned off
on May the 22nd
1917.
Roy moved to farming fruit,
but he lacked this skill
and half his strip of land

was barren, alkaline
and suddenly his farm
became unusable
its fruit yield cut in half
and insupportable
and so his venture failed.
In desperation Roy
obtained a country inn
and in the interim
his older sons were gone,
drifting off from school
to sample city life
while Roy had ended up
with his labor out for hire
and mending country roads.

XXIV

In 1924
Jack reached the age of twelve.
To celebrate that fact
on the threshold of his teens
his rite of passage was
to take a midnight dip
in the January canal,
an act in Huck Finn style.
He proved his manhood too
displaying deadeyed aim
to kill a neighbor's cat
a widow's pride and joy
with a .22 through the brain

then like a child he begged
his friends to hold their peace
and not to tell on him.

XXV

In the fall of '24
Roy Pollock took a trip
with both his youngest sons.
They drove to Indian lands
to see the Tonto Forest.
Along a canyon's walls
cliff-dwellings up on high
were pre-Columbian.
Six hundred years before
they were inhabited
by an unknown tribe.
There Sande placed his hands
in small imprints that he saw
on dull adobe walls
and found these tribal prints
exactly fitted his,
but as his dad explained
no "race of pygmies" but
the *women* of that tribe
who did the mason work.

XXVI

Jack was first dismayed
then grew hysterical

for Roy had disappeared
exploring an old cave.
Roy climbed up into it
and almost lost his life
pinned down there by a rock
that shifted with his weight.
At last he thrust the rock
aside and slithered down.
"That was a close one" said
Roy laconically.

XXVII

In 1948
in *Canvas IA* Jack
remembering Sande's act
in that abandoned cave
put his handprints on
the surface of his paint
to show the work he did
as ancient men in caves
had plastered up their prints
as their signatures
and acts of human touch.

XXVIII

When sixteen Sande bought
a car, a Model T.
It cost a whole twelve bucks.
"There wasn't much in it"

Sande said, and he
shared out repairs with Jack.
The car consisted of
a basic flatbed frame
and windshield, steering wheel,
two weathered leather seats,
and four cornhusker tires.
To make these remnants go
took all their time and strength
restoring, patching up.
The engine belched out oil.
To judge by Frank's report,
they spent more time on it
in service in the yard
than driving on the streets.

XXIX

If the Model T
refused to start that day
they'd hire a substitute,
a rented Model T
for fifty cents an hour
and leaving Riverside
on weekend trips they went
to Wrightwood mountain-bound
to where Roy Pollock worked
due north some forty miles
and once their Model T
had rattled out of sight
they'd tear a plug of chaw

tobacco for the ride.
"It felt *real free*" Frank said
"to be away from Mom."
Jack's concern for cars,
his use, abuse of them
begins with this shared one
when at Riverside.

XXX

In 1926
around Fredonia,
its spread of sagebrush flats
and on Kaibab Plateau
a hunting party came,
by sundown reached a draw
beside a waterhole
where cayuses would drink
and camping overnight
the four men and two boys
descended to the draw
then crawled the last few feet
to stalk the animals.
They heard the cayuses
approach the waterhole
with tails that hit the ground.
The beasts were beautiful
and shook their lengthened manes.
"We shot as they approached"
Robert Cooter said,
Jackson's friend at school.

"Some fell immediately.
The rest with drum of hooves
in clouds of yellow dust
vanished off the flat.
We shot them and walked off.
I'm still ashamed of this.
This killing for killing's sake."
Jackson, shocked as well,
recorded this grim scene
among his memories,
used it to vitalize
and motivate his art
behind his images—
those handsome cayuses
shot at a water hole,
condemned to violent death.

XXXI

In 1927
after weeks of work
to fix their Model T
Sande and Jackson drove
away from Riverside
through fields of filaree
Wrightwood-bound again
where Roy, their dad, was boss
surveying county roads
then headed Barstow way,
Mojave white in heat
and as they speeded up

Sande turned to see
a wheel which rolled along
beside them, one of theirs.
The car cruised easily
balancing on three wheels.

XXXII

"Sande had a girl
and I would have a girl
but Jack would be alone"
Robert Cooter said.
Soon Jackson stayed at home.
He would never date
from lack of interest
in girls or women friends.
His feelings never showed.
They stayed interior
until much later when
art granted him release
to work his conflicts out
in terms of shades and hues,
figuration and
non-figurative design.

XXXIII

For jobs at summertime
Roy hired his youngest sons,
surveying for new roads
in Colorado near

that huge gash in the land
where Grand Canyon ran
and Jack and Sande camped
beside its Northern Rim
whose raw dimensions were
some eighteen miles across
and east-west fifty six,
a mile down to its floor.
They smoked pipes at the rim
and marveled as all day
cloud shadows came and went.

XXXIV

Jackson at this camp
changed his attitude
when barely fifteen years,
a big lad for his age
already five foot ten.
One paternal friend,
a father substitute
whose name was Louis Jay
encouraged Jack to drink.
Roy did not object.
He loved cheap booze himself.
Strong drink could make a man.
To start with, Jackson had
a lowered tolerance.
His friends reflected that
one drink, a single sip
made him lose control

then demons were unleashed.
It was to *hurt* himself
Stanley Hayter said
when Jackson told him this,
a streak of self-abuse
and social deficit
for the "life" he could not live,
his weakness chemical.
His personality
altered suddenly
when drinking alcohol
and drinking it became
his lifelong nemesis.

XXXV

At this time loathing school
as he returned to it,
his Canyon stay still fresh
with its colossal scale,
dramatic lights and depths,
its colored amplitude,
and the new thirst that he'd learned
for lethal alcohol
and hating every sport
(called "yellow" by his peers),
Jackson staged revolt
at all things communal.
Girls held no interest.
Socially inept
and inarticulate

he loathed community,
all group values he disliked,
a loner in himself.

XXXVI

Parading as cadet
his leggings all undone
in his slipshod uniform
Jack shouted out an oath
and struck the officer
who'd scorned his sloppy dress
and forthwith was expelled.
Allowed back for two months,
Jack quit in early March
and then he disappeared
until the start of fall.
When Frank located him
a full six months had passed.
Dishevelled, all beat up
Jack on a squalid floor
lay smashed with alcohol.

XXXVII

Was this the interval
when lost to history
later Jack confessed
to an artist friend
that he had then endured
a homosexual rape?

XXXVIII

Originality
is rarely obvious
especially when young.
Who could know back then
Pollock would surpass
in only two decades
all other artists when
he rendered through his paint
a new reality,
transforming values, worlds,
fresh ways of making art?

XXXIX

Jack went from Riverside
to Manual High, L.A.
in summer '28
in another change of home
and more adjustment but
his new school offered art
in its curriculum.

XL

At school Schwankovsky was
the first one to instruct
Jackson in how art
can widen consciousness
and stimulate young minds

experimenting with
materials and paint.
"Let go your mind and paint
whatever's in your thoughts"
was Schwany's chief advice.
This was a bold first step
of trusting to yourself
to furnish from within
until you could explore
the feelings you possessed.

XLI

Schwany's class was fun.
He read poems as they sketched,
played music during class
to influence their style.
He wanted students to
paint vivid dreams they'd had,
combine materials—
contrasting surfaces
in bold experiment,
mix glossy smooth with matte.

XLII

In his senior year at school
Jackson had become
a keen theosophist
at Ojai summer camp.
On every working day

he was seated at
Krishnamurti's feet.
From boyhood Jackson had
struggled to fit in,
stark failure the result.
In Krishnamurti's view
attempting to fit in
was a grave mistake.

XLIII

As Jackson could not draw
when Krishnamurti said
"Appreciation of
all things beautiful
lies within the self"
he helped Jack keep alive
the tender dreams he had
of a life in art.
When Krishnamurti said
"Talk is little worth.
Experience alone
leads to proper growth"
Jack saw good sense in that.

XLIV

When Krishnamurti said
"The artist's foremost task
bypassing intellect
is forge a living link

with what we feel within,
our actions and our deeds,"
his message helped to heal
the conflicts Jackson felt.

XLV

When Krishnamurti said
"Rebellion is the key
to making a strong bond
between impulsive thought
in deeds which carry out
those notions one has thought"
Jack agreed with him
forgetting in his zeal
rebellion has a cost
like any deviance.

XLVI

Jackson's sketches were
embarrassingly crude.
"Cold" and "lifeless" were
the adjectives some used
when speaking of his art.
Explaining what he sought
he was illogical
and inarticulate.

XLVII

That summer Jackson went
to where Roy Pollock worked
at Santa Ynez camp.
They had a difference.
Roy did not approve
of Jackson's interests,
especially his art.
They were not practical.
Roy blamed his stubborn son
calling him a bum.
They tried to settle things
by the use of fists.

XLVIII

Three times within the year
fists had settled things.
Life was all violence.
Jack hit an officer
while still at Riverside
and then the football coach
who wanted to recruit
Jackson for the team
because his build was large
(he hated contact sports
or even to be touched
for this reminded him
of contact with his mom,
her constant babying)
then finally his dad,

with one sure consequence.
Nevermore would Jack
do manual work for Roy.

XLI

Tolegian was a friend.
He shared Jack's interests
in art and alcohol.
Tolegian once declared
"In drawing Jack was *gauche*
when likeness was required.
He worked so hard to make
sketches anyone
could draw so easily.
It took no special skill
but what it took he lacked."

L

Sande said the same:
"Jack made no images
from other images.
He could not copy them.
If you had seen his work
you'd think him better off
in plumbing or in golf."

LI

Tolegian recalled
a time when Pollock tried
to do away with him.
"I was at the wheel
of the ancient Model T.
We worked at a mountain camp.
We took the two-man saw
to sharpen it each night
but Jackson nursed a grudge
that I'd not been pulling right.
Then Pollock seized the saw
and with no warning word
pushed it at my throat.
If I'd not safely steered
into that mountainside
we'd have driven off the edge
and dropped two thousand feet
to the river down below."

Book III

Apprenticeship in New York: The First Years

I

'30 was the year
that Jackson Pollock made
his planned trip to the east
to learn artistic skill.
On 10th September he
left Los Angeles
for NYC to join
the Art Student League where Charles
pursued a course in art
with T. H. Benton. Charles
was Benton's favorite.
Charles drove his Buick and
they took the northern route.
Until this trip took place
Paul Jackson Pollock was
the full name Jackson used
but all Jack's friends agreed
the name was ponderous
and so they dropped the "Paul"
before they reached New York.

II

Enlisting in the League
Jackson Pollock was
younger by a year
than young Picasso was
when first he came to France
some thirty years before.
Picasso had a name,
was thought a prodigy
while still he was a child,
but Jackson Pollock was
callow and uncouth,
an anti-social man
inarticulate
rigged out in cowboy garb
and would not make a name
till fifteen years had passed
when asked by Guggenheim
to show his newest work
mid-way through the war.

III

In New York Pollock joined
the class that Benton taught.
Thomas Benton was
a staunch conservative
in style, artistic taste,
considering true art
no "pretty pastime" but
athletic, an event

in manly exercise
involving structure and
all things muscular.
Benton's teaching had
two basic principles:
"You have to know what are
relationships between
the 'hollow' and the 'bump.'
When you have mastered that
you have the whole thing pat."

IV

His style was Mannerist
and oversimplified
from *contrapposto* twists
and stress on conscious craft,
its meaning plain, direct.
Loathing the surreal
Benton gave no chance
to work for subtler things
and no unconsciousness.
All abstraction was
anathema to him.

V

First Jackson lodged with Charles,
his brother having gifts
that Jackson wished to gain
for Charles could draw with skill
and he was popular,

an easygoing man
without ambitious drive.
He never lacked for girls
so Jackson envied him.
He plotted to supplant
his brother's place as he
was Benton's favorite.
Drive was his ally here.
Jackson took two years
replacing Charles till he
was Benton's favorite.

VI

Jackson was obsessed
with learning how to draw
as Charles and Sande could
so he would labor on
a torso or a dress
and try to get it right.
Joe Delaney said
"he wasn't happy till
he had the thing he did
like it ought to be
but it never was...
reworking hip or thigh
or folds of drapery
until his sketch was black
with frenzied pencil marks."

VII

On Jackson Benton said
"He is out of his field
his mind incapable
of being logical.
There is no sequence when
he tries to make a sketch.
He is unteachable."
Benton also said
if Pollock's portraits failed
it was because they lacked
the "human element."

VIII

Years later Jackson said
that Tom's strong influence
caused him to react:
"He drove at me so hard
with realism alone
I bounced right out into
non-objective work."
So Pollock learned from Tom
though it was negative.

IX

To George McNeil Jack was
"a very macho man
and drinking his big thing...
He was no joiner and

found politics a bore.
In him was emptiness.
You felt it in his talk
and in the way he looked."

X

"Jack could not train his hand
to mark the lines beneath
the sheet on which he traced"
Peter Busa said.
"Instead of tracing he
would set the paper next
to what he wished to draw
and copy it freehand,
avoid the hardest parts
(the profile, body, limbs)
just lopping off all hands
and leaving faces blank
as much too difficult."

XI

In McDougal Alley,
a sidewalk stretch downtown,
Jackson held a show.
Beside the curb for hours
he hoped to make some sales
of the paintings he displayed.
Five dollars was his price
for a signed original.
He sold not a single one.

XII

Tom Benton was convinced
that talent in a man
if he drew easily,
was not the vital thing
which guaranteed success.
Determination gives
the necessary drive
to win through in the end
and gain the higher state.
Tom cited Ryder who
could never draw as well
as Winslow Homer did
in shipping tossed by storms
but captured with his brush
as it was turbulent
the very pitch and roll
a nervous vessel makes
when it negotiates
a raging, roiling sea.
So Ryder had the edge
on Winslow Homer as
his sole ambition was
to be great in what he did.
Jack's lack of talent seemed
an unimportant thing
for he was focussed on
a single aim and so
he won through in the end.
He had that *inner drive*
that greatness most requires.

XIII

Jack's student sketches show
the copies that he made
from many a masterpiece:
Rubens, Rembrandt, and
Michelangelo,
Tintoretto and
El Greco specially,
all Benton's favorites,
and from antique copyists:
Cambiaso, Dürer, Schön.
Jack's drawings emphasize
his rhythmic energy
and strong diagonals,
his *contrapposto* grasp
forced gesture to the full,
his style more personal
than was available
in the Renaissance or Baroque.

XIV

Within Art Student League
(the year was '31)
Jackson shouted out
as the class composed a sketch:
"I've had enough" he screamed
then roared "I gotta get
the hell from outta here"
and rushing from the room
his action stopped the class.

They could not understand
the demons troubling him.
His tensions built until
they made him maniac.

XV

Midsummer '31
when in Los Angeles
Jackson Pollock met
a man who shared the same
committed view on art.
His name was Reuben Kadish.
Jackson Pollock liked
Reuben's feel for art,
its power to arouse,
persuade and implicate.
Kadish's approach
in art like politics
was earnest and direct,
committed utterly
to social betterment.
His work lacked urgency
and yet he recognized
Jackson's raw power and
the huge reserves he had,
artistic energies
which some day would break free.
Immediately he saw
what it would take the world
so many years to see

that this man, if he found
what in him *could* be found,
would change the face of art.

XVI

Kadish clearly saw
despite Jack's lack of skill
he brought a living feel
to things inanimate.
"When Jack examined things
it was as if they were
for him to realize
the life that lay within."

XVII

"A river boulder's shape
long fascinated him.
We got that boulder out.
It took the two of us
every ounce of strength
to haul it up the bank
and put it in the car.
He took it to his yard
where challenged by its shape
he planned so many things
whenever he came West."

XVIII

In August both men went
in record-setting heat
each day for two whole weeks
across Los Angeles
and visited museums,
bypassing masterpieces
for ethnographic arts:
wicker baskets and
carved masks, ceramic bowls,
weapon hafts and hilts,
varied tapa cloths,
Haida cedar hats.
"We'd eyeball these for hours,
knew where the vigor was,
where was *real* energy."

XIX

What Gauguin had described
prophetic in his time
Reuben Kadish told
to Jackson when depressed
about his wretched work
and tried to bolster him.
"Some day one will come
and work with color, tone,
no images in mind,
no reference at all
to what is natural

and the outcome then will be
like music, musical."

XX

In New York late that year
depression struck Jack down
as it did earlier
when he was still at school
at failure to fit in,
its cause now doubt that he
was competent in art
within a cycle of
self-abusive fears,
no feelings of self-worth
enlarged by alcohol.
He started to destroy
the art work he had made
so ruthlessly that Charles
had intervened to save
what canvases he could.

XXI

"Jack's perspective was
on the outside looking in"
Elizabeth had said
(she was wife of Charles).
"Ours was a culture of
big spaghetti meals
and how to save the world.

Someone's failure gave
great delight to Jack.
He was mean-spirited
and demons filled his mind."
Such anti-social traits
she found were permanent.

XXII

When brother Frank arrived
at the studio
which Charles and Jackson shared
the paintings facing him
were those of Charles alone
while Jackson's faced the wall
as he was ashamed
of anything he'd done.
While the brothers and their friends
were partying that night
Jackson's paintings still
were turned towards the wall.
Eventually when drunk
Jack was abusive to
Rose, a visitor.
All women made him cower.
He had no warm approach,
was all tied up within
because he loathed his mom.
When Marie intervened
(she was the wife of Frank)
Jackson in a rage

taking up an ax
located by the stove
he placed it to her neck.
"I like you, Marie" he growled,
"I'd hate to chop your head."
While all dumbfounded watched
he turned and brought the ax
down on a portrait which
was the work of Charles
(already it was sold)
and split it clean in two,
the ax wedged in the wall.
For his folly with the ax
Jackson had to find
another place to stay.

XXIII

In 1932
Roy Pollock died in March
expiring suddenly,
a disappointed man.
Roy thought his youngest son
had become a bum
and Jack felt guilty that
he had failed his dad
in having no career.
While art was nebulous,
it was not practical.

XXIV

Frank, Roy's favorite,
said this of his dad:
"He deserved a better break.
If dad had persevered
in Arizona he'd
have been a real success,
at last a wealthy man."
(Roy's slow death began
some sixteen years before
when Stella argued that
they move from Phoenix to
start fruit farming in
California).
"It wasn't the hard work
that had finished him—
the *betrayal* did..."
Mother had her boys—
Frank thought but could not say—
she'd gotten what she wished—
she'd had this family,
not missing Dad at all.

XXV

In summer '32
away from Benton's class
and rivalry with Charles,
Jackson's drawing showed
new possibilities,
some novel elements

that were spontaneous,
proportions of a man
impatiently astray,
his forms gargantuan
as Orozco's were
in his *Prometheus*
filling one whole page
and what began as folds
which swathed a Greco saint
for Jackson soon became
Orozcolike—displays
of lights in tandem with
dark chiaroscuro shapes.

XXVI

Pollock's early works
are all dramatic ones.
His *Camp With Oil Rig* comes
from '30–'33
suggesting many things:
arrogance and haste—
man's sheer exploitiveness,
his disconnectedness,
at most an earthly rape,
the derrick standing stark
dramatic in its shape
and tilted poles to left,
two tilting verticals
in Bentonesque technique
to open up a space

for brief untidiness
through Pollock's artistry.

XXVI

At Christmas Eve when drunk
Jack crashed an ornate church—
it was Greek orthodox—
and to the altar lurched
knocking all aside
candles chalice pyx
the gilded crucifix.
Arrested by police
Jackson spent the night
of Christ's Nativity
and cooled his heels in jail.

XXVII

This happened at the time
that Jackson finished up
two violent canvases.
Within the first he shows
his self-abusive streak
yet terror's in his look
as his *Self-Portrait* shows
Jackson as a child
nine or ten at most
in scumbled red and white
with loathing in his eyes
florid, choleric

and interrogative
as if he'd controvert
the viewer's attitude
of shock or wry disdain
at his destructive stance
posing questions of his own:
Why has the world done this?
It does not understand
the trauma that I have!

XXVII

The other work reveals
a heavy-bellied hag
(*Woman* it is called)
shown in an attitude
of "kicking up her heels,"
her stance voluptuous
with earrings and one shoe
(it mimes *Olympia*
with one shoe on her foot).
Behind this monster stands
five sons and their mom
and all stand naked there
as if in triumph for
the human genesis.

XXVIII

His drinking worsened and
on one near fatal night

Jackson threw himself
from a Hudson River dock
and tried to end his life.
Tolegian followed him
then dragged him to the bank.
By 1933
Nathan Katz averred
it was common knowledge that
Jack's eventual fate
would be suicide.

Book IV

Apprenticeship Prolonged

I

When Jackson Pollock met
David Siqueiros they
developed a rapport.
Siqueiros overturned
a full six centuries
of art discoveries,
his skill dispensing with
preliminary work.
All was spontaneous.
No longer was there need
for fitting every sketch
to complex composites
and gessoing his sets
and mixing tempera
with white or yolk of egg
illuminating first
a tiny model set
and transfer of cartoons.
He did away with this,
firing Duco jets
on flats upon the floor.

II

Siqueiros was Jack's guide
to murals tall and strong
never working from
a cartoon or a sketch
as Benton always did.
Siqueiros worked direct,
no mock ups and no molds
to manufacture scale,
no volumetric tricks.
Nunc dimittis was
the order that he gave
to brushes as a tool:
"Let's pasture that foul stick
with hairs stuck on its end!"

III

Another Mexican
Orozco had great power.
His shaping hidden things
suggested through his scale
and how he organized
things that were otherwise
inexpressible.
His stark *Prometheus*
was Jackson's touchstone for
an elemental power
near Michelangelesque.

IV

Jack liked Orozco's scenes
Gods of the Modern World
especially those five
dark skull-faced men who stood
in academic robes
and viewed a skeleton
half human and half beast
in act of giving birth
upon a bed of books.
A skull in mortarboard
who served as midwife raised
a newborn skeleton
through worlds of death-in-life,
child never to be born.

V

Orozco satirized
an education that
would shackle all for life
from embryo to corpse
so nothing could emerge
except a skeletal
delusion of a soul
insubstantial, caught
in endless agony.

VI

For some weeks Jack shared rooms
with Peter Busa. There
the landlady they had
served baked beans every night.
Busa once remarked
he rode the rails and "wolves"
had violated him.
He'd done the same to them,
to new youths on the line.
Jackson then had said
he had a problem too,
and had to work it out
but family rectitude
could not deal with this.
Busa thought it was
abnormal sexual drives:
"Is it alcoholism?"
"That's only part of it...
alcoholism is
what is *caused* by it."
Jackson said no more,
was silent for a time
then said he did not know
what it was himself.
Busa filled the gap:
"I was sure he had
encounters once with men.
He'd not need anyone
to tell him that he had
homosexual drives.

All I used to say
was 'Any port in a storm.'"

VII

Peter Busa saw
how Jackson could relate
to metamorphic forms
of men and animals
many Picassoid
quite fascinated by
the way two animals
or sometimes more than two
would fuse and blend themselves
combining strengths through these,
chimeras though they were
finally combined
within fantastic art
like totem images.

VIII

On visiting museums
Jackson would look hard
at everything he saw
but he was taciturn.
He had the keenest eye
for forms and images.
Ideas by themselves,
"isms," art tendencies
made no sense to him.

He couldn't take them in.
Pollock thought they were
incomprehensible
and thus irrelevant.
Intensity alone
is what he'd register.
The *image* was the thing.
It was a talisman,
mandala for his mind,
the *symbols* that he felt.

IX

Orozco taught Jack how
to fill up a large space,
enlivening it so that
it was continuous,
hypnotic to the view,
arresting to the eye,
relentless synergy
of men and animals.

X

Jackson had to have
external models for
the pictures that he made
but later on he learned
one could not borrow from
examples found outside
and he would have to find

that strength *within himself*
to work out *his* design.

XI

Jack bought a violin
and tried to teach himself
to get a tune from it
but broke it into bits
when it refused to play.
He took the mouth harp up
and played it well enough
to join Tom Benton's band.
"Can't play a damned thing much...
puts me to sleep" he said.
"I get a kick from it."

XII

Defending Jackson once
for lack of drawing skill
and failure in technique
Barnett Newman said
"Let's ignore the hand.
It's the *mind*—not brain, but *mind*—
soul, concentration, gut."
Newman was right on that.
"I've seen him come" he said
"from out his studio
just like a washed-out rag."

XIII

Late 1934
Thomas Benton wrote
Jack's work was promising:
"The sketches that you left—
Your work magnificent,
your color beautiful.
You have the stuff old kid.
All you have to do
is to keep it up
but I do not... feel
the lack of drawing in
the stuff that you left here.
It seems to go without it."
Of Jackson Benton said
he was a "genius."

XIV

At Axel Horn's one day
Jack unrolled some cloth
and laid it on the floor
dripping paint on it,
eager to duplicate
Siqueiros' bold technique.

XV

But at a farewell meal
for that fine muralist

bound next day for Spain
to fight the fascist threat
at the point where guests
had raised their drinks to toast
Siqueiros on his way
they saw that he had gone.
Jack too had disappeared.

XVI

After a short delay
they both were found beneath
a table wrestling hard.
What words had passed between
the master muralist
and his erstwhile friend
nobody could say.
The bitter wrestling ceased
when Sande intervened
with a deft right to the jaw
knocking Jackson out.
He was carried out by guests
into his Model A.
Sande drove him home.

XVI

Mervin Jules remarked
"When sometimes Pollock toiled
inside our studio
that stood in Union Square

we watched him at his work
and no one worked that way
as it was singular.
He'd set a canvas up.
He'd put it on the floor
and spatter it with paint.
This underpainting was
the first stage of his scheme.
Like Michelangelo
what he saw in clouds
possessed artistic form.
He let it lie a time
then he would scrutinize.
Images appeared.
This was a stimulant
to notions and ideas."

XVIII

Jackson learnt to sculpt
to obviate the need
of drawing lifelike forms.
He prenticed with Ben-Shmuel
soliciting through stone
what his shape required
with a craftsman's innate sense
as Leonardo did
and Michelangelo
who sensed those inner shapes
and freed them from the stone
in which they were interred,

but Jackson soon was bored
and stone proved difficult.
The chisel was too slow
to register each change
that surfaced in his mind,
each chip so definite,
too indurated for
the image that he sought—
a fluid thing, a loose
and ever-changing shape
that only oils could mold.
He carved a single piece.
It was significant—
a death-mask for his dad.

XIX

"The Project" was devised
as part of The New Deal.
It started August 1st
in 1935
when artists were employed
to paint for offices
and clean up monuments.
The regulations were
those of working men.
They needed to clock in
sharp at nine A.M.
clocking off at five,
but one cold day a friend
saw Jack pajama-clad

with work beneath his arm
rushing to beat the clock
anxious to clock in
with only seconds left.

XX

At a dollar seventy-five
(his hourly rate to start)
Jack cleaned up monuments.
Soon his wage went down
to a paltry eighty cents.
Why was his pay reduced?
When working on a horse
(its rider Sheridan
the Union general)
Jack scrubbed its phallus up
until the scrotum shone
and from the gaping crowd
who watched him at his work
burst out loud guffaws.

XXI

Jackson's recent work
though academic still
showed fresh experiment:
The Flame and *Going West*,
his *Composition with
Vertical Stripe*, and *with
Banners and Figures*, next

a *Panel with Four Designs*
full of movement, rhythm
and ways to dramatize
his spatial elements.

XXII

In summer '38
upon the failure of
his would-be amours and
affairs that petered out,
Pollock tried at last—
he was then desperate—
to finish himself off
and drown his sorrows in
a monumental act
of public drunkenness
within The Bowery.
It lasted four full days,
four full days, three nights
consuming rotgut wine
in such great quantities
the gutter was his bed
and it was urine-stained
then moved on by police
and in the interim
was fired from the Project force
("Continued absence" was
the reason that they gave)
then was admitted to
Bellevue Hospital

then four days later to
White Plains-Bloomingdale's
not discharged till fall
when he had to promise that
he'd never drink again,
a vow he could not keep.

XXIII

Thomas Benton had
but little color sense
fearing pigment's strength
so Jackson Pollock was
in awe initially
of the strength that color held
and painted dulls and drabs,
pale pastels, residues
subdued by dust or mud
as if the world he viewed
was bleached or oxidized,
puce or taupe or beige
till Lee converted him
to color's tension in
the paintings of Matisse,
sheer worlds of vividness
and Pollock then became
the finest colorist.

XXIV

Now Jackson learned that paint
was not a passive thing
which he could mold at will
but a storehouse for
those pent-up psychic powers
from which he sought release.
The finished canvas gave
a surface so alive,
so sensuously rich
that earlier paintings seemed
poor compared to these
and made of camouflage.
On a 1940 night
he tore up most of these
and slashed repeatedly
with a kitchen knife
works that were Bentonesque
and threw these shreds outside
where they floated to the street.

XXV

At this anxious time
with nations close to war—
war on a global scale—
Jackson often saw
awesome *Guernica,*
Picasso's masterpiece.
He went deliberately
at different times of day

in varied mood and light,
was so obsessed by it
that hearing someone make
disparaging remarks
about the masterwork
told him "Step outside"
and challenged him to fight.

XXVI

At last "The Project" closed
and all the canvases
were taken off their stretchers
and slated to be sold
like sprouts or broccoli
by the gross or by the pound.
A plumber bought the lot
to insulate his pipes,
but when these pipes got warm
the linseed oil smelled foul
so he sold them off as junk.
The man who purchased them
troubled by the smell
sold them once again.
The whole thing ended up
with the owner of a shop
purveying battered books.
There they were displayed
and piled on tables till
acquired by Benevy
a dealer in art junk.

He paid three bucks per oil
and that's how he acquired
fine art extremely cheap:
Joseph Solman, Alice Neel,
Mark Rothko, Jackson Pollock,
and Milton Avery.
He managed to acquire
two Pollocks for six bucks
while now a minor one
is fifty grand at least.

XXVII

Emerging from the West
Jack loved things Indian,
admired what Navajos
depicted there in sand
and their brightest tints
blues yellows reds greens blacks
the geometric forms
of Tlingit Tsimshian shirts
and Chilkot blanket-wraps,
the interlocking beasts
on Kwakiutl crests
and Haida totem poles,
slim Sisiutl snakes
and eagles ravens whales
carved on a talking stick
with half and double men
or men placed upside-down

inverting values there
of peace or war or clan.

XXVIII

Then Jackson Pollock met
John Graham as war neared.
Both shared an interest
in all that's primitive
and Graham aided Jack
with great encouragement
divining that this man
if given full support
would break out on his own.
He organized a show
where Lee Krasner and
Jackson Pollock were
to be exhibitors
and so at last they met.
Birth was the painting that
Jack exhibited.
He later gave Lee it
as token of his love.

XXV

Birth has vibrant forms.
The shapes that it portrays
show circularity
and angularity
played out against themselves—

dynamic genesis—
creation in its terms
and firm with emphasis
through enigmatic masks.
It is parturient
and also Picassoid,
but when she saw it first
Lee knew immediately
this was uniquely his.
It was more lyrical
in color and in sweep
than what Picasso did
and when he gave it her
the gift was meaningful.
As an artist he was born.

Book V

Life with Lee

I

Lee entered Jackson's life
when he was 29
and she was 33.
She called on him one day;
he lived in the next street.
Soon after this she thought
his work original
and they quickly hit it off.
"I was drawn to Jackson
and fell in love with him
in every way one can—
mental, physical"
and "on two legs" she said
he was "the sexiest thing."
Lee's intuition sensed
that there were many things
that he had to say
especially in art.
His personality
was vibrant with new forms,
unprecedented work,
a power he had within,
the strength to innovate.

II

To whom shall I hire myself out?
What beast must I adore?
What holy image is attacked?
What hearts shall I break?
What lie must I attain?
In what blood tread? Lee wrote
and placed it on her wall
in Delmore Schwartz's words
in his translation from
Rimbaud's *Term in Hell*
anticipating how
Jackson's life would merge
with the life she offered him,
unite his life with hers
in marriage-unity.

III

Lee Krasner soon became
a central guide for Jack
and woman to his man
not to show new art
(already he knew that)
nor to train his eye
(that had long been trained)
but in advising him
where his work was strong
and what in it was flawed.
She was his editor
and made a home for him,

brought order to his life.
Her career took second place
for a whole decade.
He was her artwork now,
supplying him with warmth
no other human could
and grounding Jackson in
a felt reality
so demons were allayed
and he could plan his life
in undistracted work
and reach maturity
unimpeded by
his demonic needs.

IV

Jackson finished works
he'd labored on three years.
Naked Man with Knife
was the first of these
enacting an event
when once Tolegian
on waking in the night
found Jack bent over him,
a blade held in his hand
and gesturing to strike.
Did the painting come from that?
Was its origin a dream?
Naked Man with Knife
Pollock gave his mom—

a work she did not like
and Jackson surely knew
it was too violent,
overtly masculine,
so he had found a way
to denigrate his mom,
to pay her back once more
for what she did to him
when he was a child,
just raw material
for all that she desired,
confusing for his sex
to have him as a boy
she treated as a girl
for lifelong misery
and no identity.

V

His second work was *Birth,*
one he gave to Lee
for in symbolic terms
by joining up with her
Jackson was *reborn.*

VI

Bird was the third of these,
its image powerful,
returning to a time
when as a boy he saw
his mother string on lines

decapitated hens
watching their blood rain down
and curdle on the ground.

VII

Violet de Lazlo said
that in analysis
Jackson unaware
of other people's thoughts
relied upon himself
for what it was he felt,
solipsist to the end.
He felt autistically,
showed power in his work
but on the other side
as a man there was in him
an utter helplessness,
he was aimless, a lost child.

VIII

For others Jackson was
obsessed with having strength
to paint as he would like.
When drinking he would go
to local friends and be
destructive physically,
break up the furniture
or in a bar destroy
friends' shoes, their gloves or hats,

attack them physically
but in a "kid on" style,
tear doors off hinges, smash
anything of glass—
an adolescent trait
expressing impotence
unable to sustain
mature relationships.

IX

Guardians of the Secret,
Stenographic Figure,
The Moon Woman and
Male and Female were
four fascinating works.
Each piece took a month.
They show expanding scale,
increasing confidence,
larger far than all
that he had done before,
full of feeling for
the colors he employed
to dramatize at will
his deep polarities,
symbolic presences
ambiguous in form.
Each painting that he made
recorded deep within
some huge tectonic shift
seismic in its force.

X

When asked what style he liked
or artist he preferred
Pollock's choice revealed
a man so similar
to what he was himself.
"André Masson is
the painter I like best.
He is the only one
who really gets to me!"
Masson was extreme
head-wounded in the war
which was supposed to bring
all warfare to an end
and if a canvas failed
he flung himself at it,
slashed savagely with knives,
used feathers sand and grit
desiring to create
disordered worlds with it
that could reflect his rage,
the total hurt he felt
at man's contrariness,
his stark stupidity
of blundering to war.

XI

In Rebay's Gallery
Moholy-Nagy's work
fell from the wall and broke.

A young Rebay cadet
thinking the fragments trash
quickly threw them out.
Several visitors
when registering their views
about the art on show
felt that what they saw
would vastly benefit
by meeting the same fate.

XII

For some weeks Jackson worked
as Rebay's janitor,
in her basement made baguettes,
resigning when she tore
a corner from his sketch
then tore another piece
till only half was left.
Of her vandal act she said
"It looks much better now."

XIII

In August '43
when men were gripped by war
upon a global scale
Jackson settled down
to a long creative spell
with a dozen open cans
of pigment drying there,

Jackson working with
a canvas on the floor
yet keeping three or four
open at all times.
He'd work on one or two
while many others dried
and one left several months
thought finished previously
might catch his eye that day.
He'd seize it and repaint
as suddenly he saw
"imperfection" in its plan,
correct it with a brush
or other implement
and almost every inch
of canvas was reworked
repainting many times
pigment he applied
never carefully
in short, decisive bursts
testing each color, form
till he was satisfied—
a risky way to work,
like "playing craps" was what
Peter Busa said.
But this way was the best
that Jackson Pollock worked.

XIV

Exactly at this time
his first big sale took place.
The Magic Mirror fetched
a full five hundred bucks,
its buyer Jeanne Raynal.
This brilliant canvas shows
how finely Jackson knew
his work had subtlety.
It is a *chiral* work.

XV

For three momentous years
as the war first lost was won
Jackson Pollock traced
a mythographic art
turning on moon and sex,
conjunctive animals
he said was Jungian.
"Man in the moon? Not so.
That's a woman, taking her time,
shining on us all."
So he would howl to her
when she had reached her full.
Bucks County was the place
his running back and forth
high on a roof-tree poised
where howling like a wolf
"You goddamn moon" he howled,
"You goddamn moon!" His howls

terrified his friends
who watched the spectacle
and thought he was insane
until he was talked down.

XVI

Agreeing with Matisse
Bill Baziotes thought
that artists are deprived
of the rudiments of speech
by having their tongues excised.
There were some places where
words should not trespass.
Max Beckmann said the same:
how dissatisfied he was
attempting to express
artistic deeds in words.
Speaking of *She-Wolf* then
Jackson Pollock said
his trying to explain
what his picture meant
would only break it up:
"It came into the world
because I *had* to paint it."
"No painting" Gombrich said
"can be 'explained' in words"
but words are helpful when
misunderstandings grow
and then you comprehend
the stance an artist takes

accounting for the state
in which he finds himself.

XVII

In 1944
for a hundred bucks
T. B. Hess obtained
a Jackson Pollock work,
his *Wounded Animal*
whose central image was
a wolf or coyote with
an arrow through its neck.
Tom Hess became
the *Art News* editor.
Clement Greenberg was
the first one to respect
Pollock's attitude,
his art work as a whole.
Clement Greenberg said
that *Wounded Animal*
"is the strongest work I've seen
by an American.
This is the man to watch."

XVIII

At his first major show
put on by Guggenheim
Max Ernst in review
wrote of Jackson's art

"A wild man like Soutine."
"Very Masson" Matta wrote.
Privately they thought
his work ridiculous.
"That isn't painting" is
what Morris Kantor said,
a view most critics held.

XVIII

Several visitors
abusing the guest book
scribbled their remarks.
A few were printable:
"Unnerved by Pollock's work,"
"This guy's too sick for me,"
"I couldn't take his work.
I had to leave at once."
Another with some wit
as well as vitriol
announced it was to him
"Just an ancient belch
from Jack's unconscious mind."

XIX

In the *New York Sun* McBride
likened Pollock's work
"to a kaleidoscope
not shaken up enough.
Another shake or two

might bring some order to
the flying particles
but each participant
is not too sure of this."
It was no wonder that
not a painting sold
and just a single sketch.

XX

In *Gothic* '44
Pollock found a scale
that really suited him,
no figuration there—
just movement over planes,
its cool "stained glass" palette
and stress on all the parts
so well distributed
suggesting motions of
our posture and our walk
and human dignity.
Its plan is Arabesque
with blue predominant
playing off to green—
the balance satisfies
so Greenberg valued it
as a masterpiece.

XXII

Jackson knew the truth.
He would not fool himself.
Before he left for Springs
he had two insights that
determined how he'd live.
He felt he'd always be
homeless there inside,
a total loneliness,
a human isolate
but outside he'd found home
and Springs would be its site.
Both these truths he told
to Jeffrey Potter as
with Jackson Potter shared
a social deficit,
both human mavericks.

XXIII

They left New York in June
for Fireplace Road in Springs
near Amagansett Town,
an old neglected house
in five broad acres set
with larger trees in front
outbuildings at the back
and one sweet wash of grass
beside a shallow creek
its name Accabonac
(the folks who lived around

were known as "Bonackers")
and harbor out beyond.

XXIII

Power was on the site
but the house was bathroomless
and there was no heat,
the rental working out
at forty bucks a month,
five thousand cash to buy.
Lee would have rented it
but Jackson wished to buy—
the need for ownership
was very strong with him.
He borrowed money from
Peggy Guggenheim
to be paid off later by
several canvases.
At last they had a home
and the barn beyond
would make a studio
big enough for work.

XXV

When first he settled in
Shimmering Substance was
a breakthrough for his style,
a small bright painting made
of many hundred strokes,

the cursive gestures packed
to form a subtle mesh
of curling yellow, white.
Paint is here applied
directly from the tube
as Mondrian had done.
He used a tube of paint
and put it on direct
in favor of a pure
researching for ideals
which he could simplify
but Jackson Pollock's choice
had no philosophy.
It was a last resort,
his one remaining hope
to forge a vehicle
expanding to the full
those feelings that he had,
no longer inchoate,
exploding into shapes
where colors innovate.
It had taken sixteen years
to find an abstract style
that was uniquely his.
The paintings that he made
from 1930 till
1946
are the story of that quest,
that hunt for feeling-strength.

XXV

Most abstract artists are
tragic in their scope.
They have to simplify,
restrict their tension to
the naked way they feel
and yet this nakedness
exposes them to scorn,
the superficial view
that art should show a world,
one we can recognize.

XXVII

Jackson Pollock felt
quite ambivalent
at leaving human form
and figurative work.
The work was imageless.
Concerning *Eyes in the Heat*
"That's for Clem" he said,
felt Greenberg would approve
who knew such painting was
without illusion of
any depth in space.
Instead of this there were
unmediated forms
dispersed so evenly
across the picture plane
the way to see them was
in one glimpse all at once

and not a copy of
set objects in the world
but something on its own
complete and self-contained,
a fully abstract thing.

XXVIII

He'd now finished with the brush,
his step penultimate
to the final one he made
to *pour* his pigment on
achieving unity
his art a seamless blend
as near spontaneous
the man and substance one,
his art a mystery.

XXVIII

Hans Hofmann was a Fauve
and an expressionist
gone abstract late in life.
On visiting Pollock Hans
was shocked at the mess inside
Jack's cluttered studio:
a hundred scattered cans
crusted with dried paint
and in the midst of this
stood Pollock's thick palette.
Upon it lay a brush.

When Hofmann lifted this
the palette was attached.
An angry Hofmann said
"You could kill a man with that."
"That's the point of it"
was Jackson's sharp reply.
It was *his* studio
that Hofmann would invade
and how he worked in it
whatever state it had
however organized
was his convenience
so both stood toe to toe
and fire was in their eyes
like boxers looking out
to land a sudden blow.

XXIX

Then when Hans Hofmann looked
at Jackson Pollock's work
he asked what place in it
the realm of nature played.
"I am nature" was
the answer Jackson gave,
an arrogant retort
which was equivalent
to saying "I am God"
yet Pollock was correct.
His "I am nature" meant
that Jackson had discerned

and placed within his work
abbreviated forms
we now call "fractal" work
after Mandelbrot
a "fractal" enterprise.
Jackson Pollock was
acutely sensitive
to structures that he felt
were there within the world
but were not obvious,
the way that streams trees clouds
and everything that grows
would fork or bifurcate,
image out themselves
and what seemed chaos had
an order in its midst.
That was the job of art.

Book VI

Four Masterly Years: 1947–1950

I

In his treatise *How to Paint*
Leonardo wrote:
"I sometimes stopped to look
at dried stains on the walls,
loose ashes on the hearth,
the transitory clouds
and movements in a stream
and if I closely gazed
I would discover there
contrivances galore."
Putting his canvas down
flat upon the floor,
Jackson saw the same
as Leonardo did
with so much movement in
the stored-up energies
released in pigment's strength,
a power that could repose
within a single line.

II

Jackson tried to throw
Phil Guston off a roof
and Bill Baziotes from
an upper window ledge,
held Siqueiros on the floor
and tried to strangle him
and tried to use a knife
in the middle of the night
on friend Tolegian.
"Tried" is the active word
but never "tried" too hard
not killing anyone
until the night he died.
He shocked and scared his friends
provoking a response
directly on himself.
That was the point of it,
a masochistic ploy.
Again and yet again
we hear that Pollock hit
his friends or strangers till
they hit back in return.
His game was circular
and guaranteed response.
He sought this tension as
it made him feel alive.
You'd not stay neutral when
Pollock was around.

III

Kadish once remarked
"I found that Jackson was
an interesting guy
with things phenomenal,
a storm, no matter what,
it always challenged him.
Jack was a pantheist.
One summer's day he hooked
upon Long Island Sound
a blowfish, pulled it out.
The thing was puffing up,
Jack jumping up and down
so thrilled by its attempt
to frighten off its foe
by blowing up its bulk."

IV

Jackson Pollock changed
the course of western art.
He walked around a work
tossing paint on it
and pouring from all sides
so painting seamlessly
creating unity
from forces larger than
anything before
achieving new effects.
He said of this new work:
"There is pure harmony,

an easy give and take,
and the painting comes out well."

V

He was not the first
to pour paint in this way
but he was the first
to use it as a means
for saying major things
within his abstract art
creating new techniques
which wholly suited him
given his lack of skill
in normal draftsmanship,
his aptitude with line
and linear interest.

VII

From 1947
to 1951
Jackson Pollock's art
achieved its fluent best,
144 canvases
and each one different.

VIII

In 1947
seventeen works were poured,
the next year double this
as expertise increased
and thirty-two were formed
and in the following year
he finished forty works
then 1950 was
his most productive year
as fifty-five were poured
or more than one a week
including three some thought
were his very best:
One and *Lavender Mist*
also *Autumn Rhythm.*

IX

In 1947
a collage Jackson made
was called *Full Fathom Five*
which William Shakespeare wrote
trilled out by Ariel:
Full fathom five thy father lies;
Of his bones are coral made;
Those are pearls that were his eyes.
Nothing of him doth change
But doth suffer a sea change
Into something rich and strange—
an oil on canvas with

buttons nails and tacks
coins matches cigarettes
associated more
with burly Caliban
whose act was out of sorts,
a thing of patches, orts
than slender Ariel,
the sprite who was all charm
and ever lyrical
which Jackson Pollock poured
for sway of waters where
Long Island Sound has blown
disturbing surface waves
was fifty inches long
and thirty inches wide.

XI

For the first show Jackson had
at Parsons' Gallery
"Lightweight" critics said.
It was "monotonous"
and "mere unorganized
flashes of energy
and therefore meaningless."
One, out to scoop the rest
for poisonous epithets
"baked macaroni" called
the whole of Jackson's art.
Alonzo Lansford quipped
"his current method gives

the severest pain in the neck
since Michelangelo
painted the Sistine Ceiling
four centuries ago."
But Clement Greenberg praised
concluding from the show
that Jackson Pollock was
"Picasso's heir" in art,
"a great American."

XII

Of paintings in the show
only two were sold.
All the proceeds went
to Peggy Guggenheim
while the Pollocks with no cash
were almost destitute.
To save expense they closed
one floor of their house.
At $21 a cord
wood was a luxury
and when the weather froze
they left for NYC.
Jack tried to cash a check
and then it bounced as he
had nothing in the bank.

XIII

But Betty Parsons sold
for several hundred bucks
a work called *Shooting Star*
which Muriel Francis bought.
Jackson later claimed
"We lived a year on that
and clams that I dug up
with my toes from out the bay."

XIV

In July '48
Jack engineered a fight
with the then editor
of *Partisan Review.*
"Jack was very drunk"
Herbert Ferber said.
He ran across the floor
and pouncing on a shoe
from Greenberg's girl that night
Jackson tore it up.
The guests just stared at it
in fragments on the floor.
Jack reached the window and
made as if to jump
to the sidewalk far below.
Rothko and Phillips lunged
and wrestled Jack inside.
Gorky witnessed this
while fingering his knife.

Gorky wore a brace.
His neck was broken from
an auto accident,
his paint arm paralyzed.
A few weeks after this
when only forty-four
Gorky hanged himself.

XV

Late fall in '48
Life published a review
of Pollock's newest work
(*Cathedral* was its name).
Greenberg and Sweeney praised
but others were less sure.
Sir Leigh Ashton said
this work was "exquisite
in tone and quality.
It would truly make
an enchanting printed silk."
He wrote as if it were
a necktie or cravat,
not something three feet wide,
a mural six feet tall
and Hyatt Mayor said
"I suspect a work
I think I could have made"
implying slapdash art
which one could imitate.

XVI

And Coates had thought of it
"mere unorganized explosions
of random energy
and therefore meaningless."

XVII

Clearly Jackson's work
which had no precedent
as all his forms were *poured*—
not rendered by the brush—
and thus were "optical"—
"allover" in their mode—
was cause for puzzlement.
Few critics had the means
to understand such work.
Clement Greenberg was
the fine insightful one
who saw what Jackson did
and could appreciate
what Jackson pioneered,
what line delineates,
no longer object-tied.

XVIII

Bertha Schaefer owned
an antiques gallery

and Lee invited her
to visit them in Springs.
Bertha there admired
Lee's mosaic work,
a table that she liked
and wished to show it off
in her gallery.
When Lee's handiwork was shown
it was singled out for praise.
To celebrate Lee's triumph
Schaefer asked the pair
to dinner at her place.
Her suite was antique-filled.
Her invitation made
for Jackson's jealousy
at his wife's success.
Disaster intervened.
After having drunk
two bottles of good wine
Jackson broached a third
and gulped the contents down
as Schaefer tried to take
the wine away from him
so Jackson queried her:
"What does a dame like you
do for sex?" he said
then angrily he turned
on Bertha's furniture,
demolished all in reach,
one a Chinese screen,
a real collector's piece.

When Schaefer called police
Jackson had passed out.

XVIII

The Schaefer incident
had sounded an alarm
which Lee could not ignore.
The problem was to curb
Jackson's drunkenness.
Though he apologized
Schaefer pressed her case.
She came to Springs and charged
Jackson with assault
and threatened his arrest.
She sued for damages
confirming what Kootz said
that Jackson was a drunk.
Schaefer then forgave
and had withdrawn the charge
but only after friends—
Greenberg Wilcox Parsons
and even Lee herself
had pleaded Jackson's cause.
Lee now sought some help
to curb Jack's thirst for booze.

XIX

By the fall of '48
Jackson bought a car

which cost some ninety bucks,
a run-down Model A,
a 1930 one
later featured in
Hans Namuth's photograph
where Jackson sits upon
its vintage running-board,
depression in his soul
and looking down and out.
Later on he said
"Me and the Model A
are just plain tired some days.
I figure times like that
I ought to sit in it
and stay, not drive, but sit
until we rust away.
I guess you see the way
its upholstery
is shredded is all me."

XX

Though running rough Jack's car
gave mobility.
Stella wrote to Frank.
Perceptively she said
"He should not drive and drink
or he will kill himself
or someone." True enough.

XXI

The doctor Jackson saw
to fix an arm he gashed
from crashing on a bike
(his old Ford would not start)
was newly moved to Springs.
Heller was his name.
For Jackson he prescribed
anti-depressant drugs
and phenobarbitol
but never mix them up
when taking alcohol.

XXII

Dr. Heller gave
Jackson sympathy
and said he was on call
at any time of need.
A miracle ensued.
He did not know it then
but Jackson had two years
from late in '48
to late in '50 when
he'd given up alcohol
through Dr. Heller's help
and made exciting work.
His painting breakthrough came.
He found the means to draw
upon the awesome power
he found within himself,

not dulled by alcohol,
to search with cosmic scope
art's brilliant universe.
He poured a hundred works
and in those months he made
masterpiece upon
amazing masterpiece:
One and *Autumn Rhythm*,
Lavender Mist as well.
Greenberg valued these
as the best three Jackson poured.

XXIII

Another man who helped
to settle Jackson down
during those two years
was Roger Wilcox. Jack
approached to ask his help.
"I want to work but can't.
I've got this need for drink—
drink only to get drunk—
a thing I can't explain.
Can you tell me what is wrong?"
Wilcox answered him:
"Can't you work it out in art?
You've got essential tools,
canvas, tubes of paint.
What is stopping you?
It's only you yourself!"

XXIV

He then invited Jack:
"Each time you need to drink
please visit me instead"
so several times a week
sometimes once a day
Jackson Pollock drove
or often walked across
two miles to Roger's house.
From there the friendly men
headed for the woods
or strolled along the beach
walking absently
discussing as they went
till they came to Montauk Point.
These long walks set the scene
for Jack's creative years
of fine analysis
and spare sobriety
productive of great art.

XXV

Adam Gopnik names
the main ingredients
for Pollock's *Number 1*
(the year is '49)
creating vivid art
from a summer atmosphere:
"white maze of arabesques,"
"hot pinks and greens" in it

and its "overlighted" glint
"as California
as a Thiebaud cake."

XXVI

Tom Benton once observed
the rhythms Jackson formed
were open and suggest
a great expansiveness
which is continuous
defying "rules of art."
These also correspond
to those mechanics of
how we have sight to see
no closed peripheries
but one continuing
unending focus-shift.

XXVII

"Once Jackson spoke with me
inside a parking lot"
Jeffrey Potter said.
"I congratulated him
for how he starred in *Life*.
I called it 'finest kind'
a Bonacker remark
which meant it was A-1.
He stared at the ground so long
I would have driven off.

'What's so fine about *Life?*
For me it's more like death.'
As a Broadway manager
I knew some stars who thought
that fame was pretty fine.
It brought a look so quick
it looked more like a stab.
'They're performers and
this is what they need.
That shit isn't for a *man*.
They don't look at you the same.
You're not your own you know—
maybe more, maybe less—
but whatever the hell you are
you're not your you' he said."

XXVIII

Late in '49
New Yorker's Coates had said
that Jackson Pollock's work
was "better controlled" and now
"less strident" and it had
"a depth of feeling...sense
of stricter organization"
which added to its strength.
Of painting that he's done
"these seem to me the best."
Of twenty-seven works
a full two-thirds were sold.

XXIX

His painting known as *One*
holds these qualities:
spare yet opulent
intricate yet plain
inherent yet unique
apparent and yet real
huge yet minuscule
his painting floats in space
anxious yet serene
provocatively calm
and yet is natural
in lines which stimulate
the dreaming human mind.

XXX

Yes, *Autumn Rhythm* is this:
bare trees clear skies blown foam
first winter on the wind
with highlights of clean blue,
tan beach beyond with wrack
a naked congruence
as the year in elegy
with all its colors wan
slips closer to its home.

XXXI

Number 32 is black
in black enamel with

its backdrop canvas brown,
black stark black indeed
from broad housepainting brush.
He hurled himself at it
near fifteen feet by nine.
Instead of loops and sprays
he poured great ropes of black
as thick as knees or fists
and wound them into knots
and then he exited
across the stark brown field,
his hands black to the wrists.
He giant-stepped and went
from side to side to side.
His lines were raised and fell,
twist here and there and coil—
divided arteries
or ending up abrupt
in bursts of rigid black.
He flooded his bold line
and flung from a loaded brush,
each fling he flung distinct
from right across his barn.
Naifeh and Smith observe
this was calligraphy
but one of arrogance.

XXXII

Henry Jackson who
had known Tarawa wounds

when landing with Marines
made this frank estimate
of Jackson Pollock's work:
"He felt so deep and straight.
He painted hard and tough,
not from the fingertips.
Pollock's painting felt
in combat what I felt.
It was visceral."
Yet others later felt
his work was delicate
from knowledge of great art.
He had old master skill
in linear emphasis.
The years with Benton paid
with formal mastery
and the boy who could not draw
for lack of skill or craft
became the mastermind
and in his way as great
as earlier masters were.

XXXIII

Hans Namuth photographed
Jackson at his work.
Loathing cameras,
movies or still shots
he seldom chose to go
to the cinema.
For his frame of mind

photography was false.
It was mechanical.
The camera could lie.
"Movies keep you out
on the outside looking in.
I always want to look
at personality
or a soul x-ray.
I do not know about
photography itself.
Equipment or technique
does it add up to art?
I figure if you click
the shutter long enough
something right will come
but even then it's more
a mirror image than
a true creative act,
just making replicas."

XXXIV

Immortalizing Jack
Namuth closed his lens
in late November cold.
It was Thanksgiving Day
and both men were long chilled
and bluish from the wind
that came from Canada.
Jack lost patience at
Namuth's brisk demands

and broached a bottle of
whiskey kept for guests
and poured a tumblerful
to drain it in three gulps
then sank a second glass
and poured himself a third,
the first time for two years
he'd taken up with booze.

XXXV

When Hans upbraided him
Jack tore a sleigh-bell belt
off the nearest door
and when the meal was served
overturned the feast
sent turkey vegetables
which Lee had cooked for hours
gravy stuffing plates
a bowl of cranberries
skidding to the floor
and then he left the house
in direst misery.
His austere artistry
ended on that day.
His painting ceased to be
of much significance.
The turmoil stayed within
no longer exorcised
as it was the last four years
by paintings many works.

Book VII

Pollock in Decline

I

In 1950 when
those resident in Springs
heard that their doctor died,
the victim of a crash,
Jeffrey Potter said
to Pollock at that time
"Look at the doctor's bills
you'll save now Heller's gone."
"Shit, that's not it" said Jack.
"I hardly ever paid.
It's like I'm telling you
he was what friends are for.
Goddamit, Heller helped.
This was a doc who had
no shit in his black bag.
It's the way I want to go.
Not in the hospital...
I want to go *then*" he stressed
(*Right away* he meant
and no hanging on in pain
but death *immediate*).

II

This was reflected in
the next style he pursued.
Jackson ceased to *pour*
but now he *drew* his works,
not color's range and warmth
but funerary black.

III

Peter Blake who was
a friendly architect
said Jackson offered him
the chance to own a work.
"I said I wished to buy
but didn't have the cash.
Jack was so generous
he offered me a deal.
'Pay fifty bucks a month.
Continue for two years.
In all it costs twelve bills
and then it's yours to keep.'
I didn't have the dough
and then the prices jumped
especially when
Jackson killed himself.
Two million dollars was
the last price that it fetched"
Blake sadly reminisced.

IV

Carone was a friend.
"Late one night Lee phoned:
'Please come over, Nick.
Jackson's been out all day
and I don't know where he is.'
This was at two A.M.
I knew of her concern.
She'd come in from a chore
and Jackson wasn't home.
Some Bonackers had called
and taken him to bars.
She had no trust in them
and wondered how he fared
as some of them were wild.
I thought about Van Gogh
and how he was possessed
but he drank nothing near
what Pollock had that night
when finally he came.
The door swings open and
he's wearing a wool hat
and in he comes quite wild
and he looks at me.
I felt if looks could kill
that he would kill me then.
Lee told him to sit down
because he was so drunk
and in a violent state
and she was right to be
terrified of him.

He *was* violent.
'I've done it. I've *done it.*
What *more* do they want from me?
What more do they want?"
A winter three A.M.
and Jackson mad as hell
at what they *did* to him.
What *did* they *do* to him?
Not difficult to guess...
A homosexual rape?
"And Lee would baby him
offering him some milk
and he just standing there
losing all his mind
then up he jumps and grabs
the crystal chandelier
and it comes down on him.
He falls upon his back
against a flower pot.
Perhaps it was the shock
but he calmed down at once
exhausted, almost out.
She tried to give him milk
and told me to go home.
Now it was all right.
She would take care of him."

V

Jack loved all animals
particularly dogs.

"In a bark you hear
if you have tuned your ears
the story of a life.
Dogs have such a high
charge of energy
that if one fits your flow
you've got a one-man dog
and that is why they stick
around their masters' graves."
If Jackson could have known
that Gyp and Ahab soon
would howl beside his own
he'd have been satisfied.

VI

In *Blue Poles* 52
Jackson Pollock saved
another masterpiece.
He'd overloaded it,
the work undisciplined—
chaotic colors there—
too many vibrant hues
but then he'd salvaged it
inserting eight stout poles,
eight slightly tilted poles
at equal distances
across the painting's floor.
Three are slanting left
and five are slanting right
all taking up the strain

of color to break out—
red yellow orange with
bright silver out beyond
and all incongruous
exerting pressure on
those ragged totem poles
restraining in dark blue,
dark blue almost black
which holds the riot in
to keep it in its place.

VII

O'Hara ranked this work
as a great masterpiece
as those of Géricault,
his *Medusa's Wreck*
and Watteau's *Cythera,*
its mode American.
It is the drama of
American conscience.
Lavish, bountiful
it holds within itself
a world of sentiment
implicit but denied,
a sensual freedom fenced—
careened licentiousness—
eight totems guarding it
with native origins.

VIII

A verbal bullier
so vulgar with his tongue,
Jackson cursed poor Lee.
Both sado-masochists,
she would pay him back.
She was weaned on abuse
humiliated by
the mother-brother state
she'd borne when she was young
as her brother, Izzy, was
put on a pedestal
by their doting mom.
It was Oedipal.
Some saw as abuser Lee
and Jackson victimized.
She always censured him
and told him what to do,
what *not* to do as well,
nagging constantly:
to take the garbage out,
how act in company
and keep a schedule up,
how much cash to spend,
how loud the phonograph...
and always rode him tough.
Friends that summer said
"like a lion tamer" Lee
yelled "Jackson!" when she'd need
to bring her man to heel.

IX

Lee ordered him around
and Jackson would submit.
The next day he'd explode
and Lee would buckle to.
One day at dinner Lee
would press him to explain
the notions that he had
about his views on art
with definitions, names
to save embarrassment.
Lee one day was "a mouse"
and Jackson "a big bear"
Sam Hunter recollects
and she would dominate.
"It was almost like a game"
Harry Jackson said
to illustrate the way
they played at give-and-take.
He'd needle the hell from her.
She'd love it then she would
needle the hell from him.
It was reciprocal.
Her adulation gone
that first Lee had for Jack,
creative tensions came
to mutual benefit,
a back-and-forth that worked,
a game that satisfied
Lee's hunger to possess,
Jack's need to be possessed
without it seeming so.

X

From the fall of '53
Jack talked openly
of taking his own life.
Stella must come again
Lee thought and she would save
Jackson from himself
as she had done before.

XI

His friend Ossorio
had a litter of fine pups.
When Jack was given the choice
from the poodle litter guess
which was the one he chose?
He chose the runt of course.
It was wrong shape, wrong size,
wrong color. What of that?
Jack himself was stray,
always the odd one out
from when he'd been a boy
or even earlier
when Stella yearned a girl
and raised him first as one
so he felt deep within
he understood that dog.

XII

Jack drove his Model A
across a neighbor's lawn
and cut to ruts and welts
its gleaming velvet top
before he drove away.
When challenged for his act
Jackson justified
the damage he had done
by saying that he made
the largest painting in
the world's long history.
It would take ten grand
to set the lawn to rights
the merchant owner said.
Jack offered to return
and sign it at the base,
joked "Then you can *pay me.*"
Like every vandal act
that Jackson Pollock did
he got away with it
until the final crash.

XIII

Millie Liss explained
her trip to Paris, France
in Jackson's Model A.
"I wished to get more ice
for Zogbaum's party and
Jackson said he'd go

and asked me go with him
and then on our return
he asked me if I'd like
to go to Paris in
his ancient Model A.
We drove out to Louse Point.
He said the only way
to get to Paris was
to drive into the sea...
there's Paris at the end.
He drove right up the beach
unto the water's edge
and then we hastened back.
We were away so long
that other people stared.
All Jackson did was laugh.
This was the only time
that I was asked to go
to Paris in a car—
in Jackson's Model A."

XIV

With an ice pick Jackson struck
Ossorio's Pleyel
and hacked its keyboard up.
"I'm no damn good" he said
when with a doctor friend.
He felt Picasso blocked
all progress he could make:
"That guy's done *everything*!

There's nothing left to do!"
Although he could not know
Jackson had attained
a sure world for himself
by his own raw strength
of feeling, intellect
as later years would show.

XV

But artists were just "worms"
then from his ceiling yanked
the crystal chandelier.
When he lost confidence
he was coarse and gross
and said of Lee to friends
"Can you imagine me
being married to *that face?*"
On one fall day a storm
that came from Canada
blew his studio away
and a summer's work was lost.
When Jack saw that, Brooks said,
he broke immediately
and cried as babies do.

XVI

Asked to party at
Harold Rosenberg's
Jackson drank too much

and interrupted talk
with "What a lot of shit."
Rosenberg replied
"Don't you think you've had
enough to drink today?
Please do not interrupt.
Go have a nap upstairs."
Too drunk to take offense
Jackson left the room
then Lee in anger said
"How *dare you order him.*
He is a famous man.
You speak as if he was
just anyone at all."
As Harold made a joke
the guests began to laugh
and Lee stormed from the room.

XVII

Greenberg had not viewed
Jack's show in '52
or his in '54
but of this recent show
Greenberg tersely wrote
repudiating Jack:
"His achievement's peak
is four or five huge works
of monumental art,
but in more recent shows
what Pollock has achieved

is a cul-de-sac
which 'pleasingly' employed
raw color for itself
but now he was unsure
of what he wished to say."

XVIII

Greenberg added that
the black and white show marked
Pollock at his peak
yet Clyfford Still was one
who'd learnt to liberate
abstraction in a way
that Pollock could not do.
The works of Still had lacked
those elements which were
decorative at best.
Jackson was annoyed
at Greenberg's strictures but
Lee found his recent views
outrageous and untrue.
When Jeffrey Potter asked
how now he saw himself
Jackson answered with
his choice expletive: "Shit!
My art is all I am."

XIX

Jack said when Lee was by
he'd trouble working as
the image of his mom
came over him so strong
that he saw nothing else
and when that shape appeared
he gave up everything
erratically unsure
of art and of himself.

XX

Jackson Pollock mused:
"I've been watching flies
in my studio
the way they try to get
from out of spiderwebs
and never make it out.
They push right to the edge
like I do myself—
that edge where there is death."

XXI

When Jeffrey Potter asked
Jackson how he felt
at being a success
"Lousy" Jack replied.
"When you have achieved

it turns out you are done.
You're nowhere in yourself,
nowhere and no one.
You are caught and yet
there's nothing holding you.
You got to go somewhere
right to the edge of it
and there isn't any edge."

XXII

Signing and titling works
was difficult for Jack.
"To give my signature
is more than a goodbye.
It means the picture is
fixed in time—it's *done*
and there is death in that.
Signing work is like
that lettering on stone
above a person's grave
saying yours and *done.*"
Another time he said
making the same point
"As for my signature—
extremely difficult;
such interruption that
I've signed some on the back."
When works were sent away
he waited till they were
ready to depart

before he finished up
and wrote his signature.

XXIII

Ben Heller had advice
for Jackson at this time
when he had ceased to paint.
"I pointed out to him
that Arnold Schoenberg stopped
composing for ten years
so for a painter just
two years or so was not
much time compared to that
but he was miserable,
so very miserable.
He played good poker though.
What a poker-player!
He would bluff, would dare
and he would stare you down.
He was tough to read.
He didn't give a shit!"

XXIV

Jackson loved the sea
observing much in it:
"This ocean is alive,
full of tricks and moods.
It can slap you, pat you, and
roll you, and it is

where life itself began.
That great source stays with me—
nights, city... follows me.
The West is it some way...
roll of the plains maybe.
Out there a woman calls...
It draws you, sucks you out
then down and in, way in
and then you're home again
where it all began."

XXV

Dore Ashton visited
the new Mark Tobey show.
Once in the gallery
she saw a man who wore
too long an overcoat.
Its collar was well up
and his coat fell to his boots
upon a fine spring day.
"I watched this person as
he looked familiar.
How fixedly he viewed
what Tobey had achieved.
When he moved I saw
the man was Pollock.
I was shocked because
he looked so thin and had
black circles round his eyes.
He and I sat down

and talked on what we'd seen
on Oriental art
and Tobey's sense of it.
He admired the work
but all the time he sat
he wore his overcoat
with the collar turned right up
yet it wasn't cold.
He looked a desperate man."

XXVI

Marca-Relli said
"He loved the ancient world
not thinking it all crap.
He loved the modern greats
Picasso and Matisse—
della Francesca too,
the great Renaissance three...
Morandi for his tones
and how his bottles glint!
Just three short weeks before
we were to sail he said
"I cannot take the chance.
If I get drunk just once
there's no one there to help."
He knew that he would get
in trouble at some point."

XXVII

Castelli was a friend
who'd helped place Pollock's work
in shows and galleries.
He said Jack visited
in 1956.
"He was in bad shape.
He said he *could not paint.*
He sat in front of *Scent,*
looked at it longingly.
This painting was not dripped
but painted with the brush,
the last work that he did.
I saw him feeling low
and on his face there was
so negative a look.
Paint was something that
he could no longer do.
He was disturbed at this.

Book VIII

The Death That Jackson Wished

I

Reginald Wilson saw
that Jackson had enjoyed
every chance he had
when he was at the wheel.
"He always drove too fast
accepting any space
that opened up for him.
He quickly was incensed
if he felt anyone
infringing on his rights
to dominate the road
and drive just where he pleased.
When problems weighed on him
he loved to drive at speed.
His only instinct was
to pile up many miles
as fast as he could drive
achieving if he could
escape velocity."

II

Just after Christmas Day
hating that "Santa shit"
Jackson wrecked his car
at ten o'clock at night.
Police reports had said
there was a crash at Springs.
"Weather clear" it said
"when Jackson Pollock drove
in his Cadillac.
He left the road's north side
and hit three mailboxes
at Louse Point Road in Springs,
downed telegraph poles, went on
for fifty feet southwest
to hit a tree head on."
His hood accordioned,
through the dash the engine thrust
then past the steering wheel
where Jackson was pinned fast
and after minutes of
a dazed subconsciousness
unscathed except a bruise
he suffered on his chest
lucky to be alive
he staggered from the wreck.

III

With Lee from NYC
in his new Oldsmobile

put pedal to the floor
went screaming from the curb
ignoring every light
and crossed Park Avenue
like a missile shot in space
cars honking in his wake
all skidding to avoid
his brand new Oldsmobile.
He veered from lane to lane
seized by a drunken rage.
Stein was a passenger
(brother-in-law to Lee).
Stein was quite convinced
that Jack was bent on death
not only for himself
but both his passengers
first and foremost Lee
would do away with her
so lunging from his seat
Stein shut the engine off.

IV

Jack pale with fright one night
from one near accident
on a dark deserted road
when his control was lost.
His car had spun around
in a contretemps with death.
He did not learn from this
and next night once again

was back out on the road
with an open case of beer
beside him on the seat.

V

In the spring of '56
the only question was
how the end would be.
Would Jackson break or Lee?
Who would be the first
to let their marriage crash.
They challenged constantly.
He would beat her and
she would call police.
"I'll kill you" he would roar.
"You're killing me" she screamed
but still each clung to each,
unwilling to give up
their strange relationship.

VI

Pollock had bad dreams.
Nightmares filled his mind.
Once he dreamt he stood
upon a parapet
and all his brothers tried
to shove him into the void.
Another night he dreamt
a vacuum cleaner searched

when in a flash it changed
to one of Guggenheim's
raucous Lhasa dogs.
Her terrier attacked
and bit him in the gut.

VII

A third dream that he had
was by far the worst.
"There were two cars" he said
"and the one I'm driving rams
into the one ahead
abandoned by my wife.
Between the two wrecked cars
is a dead boy in the road."
Jack took this as a sign
that that boy was himself
and death was imminent.

VIII

He bought a hunting bow,
shot arrows in the house
with Lee convinced his aim
was ultimately her.
She was a target for
his scorn, his aimlessness.

IX

He barricaded himself
within his studio
with scotch for company
and Jimmy Yancy's sound.
Jackson locked his doors
and blocked his windows up
then turned the volume high,
as high as it would go
upon his phonograph
in crass experiment
of psychedelic sound.

X

Ruth Kligman came one day
to the Cedar Tavern which
was Jackson's watering hole.
Soon after they had met
Jackson spoke of Ruth—
of how he felt for her
in auto metaphors—
"a current model one"
so "just a bit of goods,"
"late model" and "cream puff"
and "loaded with extras too."
To Jackson these terms were
the highest praise he had
as he valued cars
for power and elegance
he thought he'd gained in one

but many times he'd crashed
by driving recklessly,
today defining as
autistic clumsiness
and too fast for the road.

XI

For Jackson Ruth had felt
a gay romantic sense
but thin as celluloid
spawned by Hollywood
and as combustible—
saw "Brando and Monroe"
in their relationship
or "Bogart and Bacall"—
polar opposites—
but the dreams that Kligman had
were also cynical.
She had to punish men
for what her father had done
in hurting her when young,
first elevating her
through charm and flattery
as she was beautiful
then put on a pedestal,
but when she told him that
she had been analyzed
to try to right herself,
to give her confidence—
"I needed help" she said—

he had ejected her
from his white Cadillac,
his con-man's equipage:
"Are you a whore or queer?
Get out of my car, you *tramp*."

XII

During his last spring
Waiting for Godot played.
Its theme was desolate,
a sense of hope against
a wall of hopelessness,
an endless round of hell
where everyone lay trapped.
"Okay I went to that
but couldn't take it and
I had to leave" he said.
(Jackson had to leave
when Lucky's rope was pulled).
Jackson went three times
but could not stick it out:
"My guts were pulled right out,
pulled backwards every time
like one of those hard births
where they must *drag you out*"
(thinking of his own).

XIII

Ruth Kligman went with him
until the moans he made
forced them both to leave
to save embarrassment.
He was *the bum* in it
wearing bummer's clothes,
no money, naught to eat
but a carrot and a swede
and then the characters
would bicker over both
the carrot and the swede
waiting for Godot but
Godot never shows.

XIV

He stared at the wall for hours.
On a trip to NYC
ran into noontime rush
but the avenue he chose
to walk the center line
was all publicity
(Its name was Madison).
Car horns honked and honked
as Jackson tried to jump
from out a speeding cab,
was restrained just in time.

XV

Ruth spent the night with Jack
in his studio.
When next day she arose
Lee then challenged him:
"Get that woman off
my property before
I call police" she said.

XVI

Lee had to get away
to distance his abuse
and planned a trip to France
giving Jack the choice
between herself and Ruth
yet the night before she sailed
she dreamt of Jackson's death.

XVII

As soon as Lee had sailed
that very afternoon
Ruth Kligman, clad in pink,
moved to the house at Springs,
unpacking her pink things
began their "honeymoon."
It lasted but a week.

XVIII

She found her kitten gone
that she'd entrusted Jack
(he had got rid of it)
and suddenly she found
he could not tolerate
jazz records that she'd brought.

XIX

He'd left her in the car
when visiting his friends
now drinking at a rate
of a case of beer a day
and he was hitting her.
At first she liked it but
she threw a tantrum and
smashed a case of glass
because she drank too much
so then he hit her hard.
She fell "like a broken doll."

XX

At a party for a friend
he "Fuck you" yelled at Ruth
which chilled the atmosphere.
"Don't boast" was her response.
It was a double taunt.
In less than three weeks she

had had enough of him,
his anger and his pain
and he was bored with her.
She went back to New York.

XXI

For the first time in his life
Jackson was alone.
Stella Sande Charles
Lee Ruth had pampered him
attending all his needs
so he had stayed a child,
was helpless otherwise.
Now Ruth was gone friends saw
Jackson walk around
as if he'd lost his mind
wandering aimlessly.
"I am lonely" said his look
and if you'd met him then
"I am lonely" was
the only words he said.

XXII

He'd made a huge mistake
in his "affair" with Ruth.
He'd wronged Lee badly and
he needed her return
so made his plans to go
to join her there in France

then they could come back
once more in partnership
forgetting in his need
the rapport that they had
had perished long ago.
He'd left this chance too late
to reconcile the past.
Already Lee had left
Paris and the Seine
to travel in the South.

XXIII

He tried to save a dog
run over by a car
but when the pooch expired
Jackson's heart was torn.
He saw this canine death
(how else explain his grief)
another sign from fate
his own was imminent.

XXIV

On an evening visit to
Marca-Relli's house
the last few words he said
before he went away
were "Life is beautiful,
the trees are beautiful,
the sky is beautiful

then why is it that all
I think about is death?"

XXV

When Ruth with Edith came
as weekend visitors
he scarcely welcomed them
dressed in dirty clothes.
When Ruth introduced
Edith Metzger to
her famous artist host
he grunted at her then
and glumly walked away.
When they had driven home
his house was in a mess.
When Ruth prepared their lunch
he waved the meal away.
Something new for him,
he drank some gin instead.

XXVI

That afternoon his guests
wore swimsuits for the beach
but first the pair had posed
for a gay photograph
that Edith Metzger took,
Ruth straddled on his knee—
with both his hands he held
the buxom thigh she had—

his eyes mere slits looked out
from Jackson's bloated face,
then both were smiling at
the loaded camera.

XXVII

And then they drove away,
not beachwards to the sea
but right out to Montauk
to visit with the Brooks
and then on their return
avoiding beach and sea
Jackson Pollock went
directly to his bed
leaving both his guests
to entertain themselves.

XXVIII

Then when he arose
after fitful rest
they had their evening meal
with Jackson drinking gin
(he had no appetite)
and after short debate
they decided to
attend a concert which
Ossorio had planned—
he was Jackson's friend,
a sugar millionaire—

at his big house, The Creeks.
But as they neared the place
Jackson stopped the car
and slumped behind the wheel.
"I'm feeling kinda sick.
I feel terrible."
He could hardly walk
but telephoned The Creeks
to say they would be late.

XXIX

Edith when she looked
saw Jackson was not well
and in no state to drive
so she would call for help
by summoning a cab.
He then lost consciousness
but while he was asleep
or maybe comatose
came Edith's voice, like Lee's,
a harsh sarcastic tone.
Jackson woke at that
and in a blinding rage
told the women to
get back into the car:
"We're going home" he said.
Edith then refused.
She was scared to death.
"He's drunk" is what she sobbed.
Ruth countered with a lie:

"No, he's not. He's fine.
Get in. We're going home."
So Edith acquiesced
by going to the back
as far away from him
as she could place herself.

XXX

He stepped upon the gas.
At that the car took off,
shot headlong through the dark
with Edith screaming out:
"Stop the car!" and "*Let me OUT!*"
Ruth pleading then with him
"Jackson, please stop now.
Jackson, *Don't Do This!*"
but he was out of reach,
his mouth drawn up in what
appeared to be a laugh
or was it terror when
abruptly the long road
began its leftward curve
and the concrete ribbon turned
to oil-black asphalt as
they reached the hidden bend
where many cars before
had ended up as wrecks—
the bend notorious—
where Jackson had himself
slowed down so many times

responding to the curve...
He did not do so now.

XXXI

He did not do so now
disoriented by
not knowing where he was
not knowing *who* he was...
perhaps a heart attack
or something blind in mind?
The sickness thirty years
and all that alcohol...
Enraged by Edith's screams
Jackson lost control
of the heavy Oldsmobile...
It bottomed down then jumped
the high crown of the road
and then on veering right
it lost its traction to
smash into the trees
and turning upside down
threw out two passengers,
the third trapped in the back
and then oblivion.

XXXII

"When I heard this car
barrel-assing down the road
that fool won't make the curve"

was what a neighbor said
and then he heard the crash.
Two women in the wreck,
one dead in the boot,
the other badly hurt
but luckily thrown clear.
Jackson also was.
He volplaned fifty feet
some ten feet from the ground
until he struck an oak.
The impact broke his neck.
He tested then that "edge,"
that edge where there is death.

XXXIII

When Lee had heard the news
that Greenberg phoned to her
she was hysterical
and took the first flight back
returning the next night.
Later on she said
that Jackson Pollock was
a Titan in his strength
though much was negative:
"Whatever Jackson felt
his feelings were more intense
than anyone I've known;
when angry, angrier;
when happy, happier;
when quiet, quieter
than anyone else I've known."

XXXIV

Four tributes testify
to what great strength he had:
"Pollock touched the truth";
"He was phenomenal";
"He saw the webs in things
and cleared them all away";
"Jackson Pollock was
one of those artists who
are midwives to us all.
They change the course of art."

XXXV

"We were with the truth
when Jack was sober but
even when he drank
he was damn wonderful.
Jack was great for me
and in the end I came
to value more the man
than all the work he did"
Clement Greenberg said.

XXXVI

"It's half-true that he was
destructive, violent"
B. H. Friedman said
"and that in the end

he destroyed himself
but there's the other half
which is his tenderness,
his creativity.
His broad ambivalence
for love and passion is
clear enough in art.
Each painting is complete
and balance is achieved
in sudden violence
or explosiveness
and in the delicate
caressing web of art—
subconscious, consciousness
connect and fuse as one
through raised awareness in
Goya's *Capricios,*
Picasso's *Guernica*
or Pollock's *Autumn Rhythm.*"

XXXVII

Gyp and Ahab howled
at Jackson's burial
both straining at the leash
as the coffin was set down
then lowered in the grave.
As Jackson loved all dogs
he would have understood
what grief was in their howls,
a canine keening for

the newly vanished soul
and its finiteness.

XXXVIII

Elizabeth Frank concludes
her Pollock study with
this fine sentiment—
Pollock journeyed to
his soul's interior
and his art bears witness to
what he found within.

Glossary

Arabesque—A style of linear ornament consisting of interlaced lines. Most arabesques are curvilinear and flowing, although some have an angular character.

Armature—Internal framework to support sculpture or painting during construction or implementation.

Abstract art—Any art in which the depiction of real objects in nature has been subordinated or entirely discarded, and whose aesthetic content is expressed in a formal pattern or structure of shapes, lines, and colors. Sometimes, the subject is real but so stylized, blurred, repeated, or broken down into basic forms as to be unrecognizable.

Abstract Expressionism—A style of nonrepresentational painting that combines abstract form and expressionist emotional value. Abstract expressionism, which developed in New York City midway through the 1940s, became fully established during the 1950s and was the predominant style associated with the New York School. The paintings are typically bold, forceful, and large in size. The colors tend to be strident, and accidental effects are often present, such as the natural flow of oil colors without restraint. The movement's single most important figure is Jackson Pollock

(1912–1956). Pollock's fluid paints and enamels were poured, dripped and spattered onto the canvas; a single color was often used to create a lacy mesh of opaque color over the surface, much like the transparent veil in a conventional oil painting.

Action painting—A form of Abstract Expressionism. Action painting is done by applying the paint with rapid, forceful, impulsive brush strokes, or by splashing or hurling it directly onto the surface, in order to create a work that records the force of the artist's feelings as well as the dynamism of the act of painting.

All-over—A method of painting first devised by Jackson Pollock in which the entire field of a canvas is covered in a fairly uniform manner, thus eschewing traditional notions of top, bottom and middle of a painting.

Asperger's syndrome—A condition characterized by sustained problems with social interactions and social relatedness, and the development of restricted, repetitive patterns of interests, activities and behaviors. It is believed to be a milder variant of autism, but without the delays in cognitive or language development. While these individuals experience attention deficits, problems with organization, and an uneven profile of skills, they usually have average and sometimes gifted intelligence. They may have problems with social situations and in developing peer relationships. They may have noticeable difficulty with nonverbal communication and impaired use of social gestures,

facial expressions, and eye contact, together with certain repetitive behaviors or rituals. Although grammatical, their speech is peculiar due to abnormal inflection and repetition. Clumsiness is prominent both in speech and physical movements. Individuals with this disorder commonly have a limited area of interest that usually excludes more age-appropriate common interests.

Baroque—The style dominating European art and architecture throughout the 17th century and persisting in some places as late as 1750. It was a dynamic, theatrical style that used realism, illusionism, ornate forms, and a blending of the arts to achieve its effects.

Beige—A yellowish grey color of undyed and unbleached wool.

Buff—A dull yellow color.

Chiaroscuro—The rendering of forms through a balanced contrast between pronounced light and dark areas.

Chiral—Not superposable on its mirror image.

Cloisonnism—The name given to a type of painting that is similar to the creation of cloisonne enamels, in which bright colors are surrounded by darker shades that serve to highlight the bright colors.

Collage—The technique of creating a pictorial composition in two dimensions or very low relief by gluing paper, fabrics, or any natural or manufactured material to a canvas or panel.

de Stijl—Or Neoplasticism, an art movement adhering to principles of abstraction and simplicity; form was reduced to the rectangle, and color to the primary red, blue, and yellow, in Neoplasticist paintings.

Ecriture—An artist's recognizable individual style or manner.

Facture—Quality of execution of a painting, especially its surface.

Fractals—Benoit Mandelbrot's term for patterns that recur on finer and finer magnifications, building up shapes of immense complexity. Cogently applied by Richard Taylor to Pollock's paintings (see Acknowledgments).

Glazing—The process of applying a transparent layer of oil paint over a solid one so that the color of the first is profoundly modified.

Lavender—A pale blue color with a trace of red.

Macrocosm—The great world, the universe, any great whole.

Microcosm—Man viewed as epitome of the universe; any community or complex unity so viewed.

Monochromatic—Containing only one color.

Ochre—A pale brownish yellow.

Optical—A pictorial field so homogeneous, overall, and devoid both of recognizable objects and of abstract shapes that I want to call it *optical,* to distinguish it from the structured, essentially tactile pictorial field of previous modernist painting (Michael Fried's definition).

Puce—A purple-brown.

Ready-made—A man-made object, usually mass-produced, that was not made with any artistic consideration in mind but is mounted or displayed as an aesthetically significant structure.

Schlock—Poor-quality or second-hand material.

Schmuck—A foolish or contemptible person.

Scumbling—To modify a painting by applying a thin opaque coat to give a gsofter or duller effect.

Surrealism—An art movement of the 1920s and later. Surrealist artists attempt to give free rein to the subconscious as a source of creativity and to liberate pictorial ideas from their traditional associations.

Taupe—A grey color with brownish or other tinge.

Teal—A darkish, dull blue color with a greenish cast.

Tempera—A method of painting on plaster or chalk with powder colors mixed with white of egg, size, etc. instead of oil.

Tondo—A round or circular painting.

Blues for Bird is Martin Gray's stunning, one-of-a-kind biography of Charlie Parker. Written entirely in trimeter, the epic biographical poem dances nimbly along in a way that echoes Bird's blazing, fast-fingered solos. Gray's marvelous use of language reflects the rhythms of jazz and the beat that lies at the heart of bebop. Indeed, *Blues for Bird* is like a piece of jazz itself: exciting, innovative, and constantly surprising.

"*Blues for Bird* shows the results of thorough research in its richness of information about Parker's life and his impact on jazz. . . . Most of the poem's readers will probably already know the music . . . For such readers the experience will be enriched, deepened by testimonies to its greatness and by the sufferings of the man who made it."
　　—Walter Cummins, Editor, *The Literary Review*

"Reading *Blues for Bird* brought back a lot of fond memories of the old days. An enjoyable and informative piece of reading."
　　—Horace Silver, jazz pianist

288 pages; 12 illustrations
$16.95 plus shipping ($3 within the U.S. and Canada; $9 internationally)
Santa Monica Press
P.O. Box 1076
Santa Monica, CA 90406

1-800-784-9553

www.santamonicapress.com
books@santamonicapress.com

SANTA
MONICA
PRESS

Books Available from Santa Monica Press

Blues for Bird
by Martin Gray
288 pages $16.95

The Book of Good Habits
*Simple and Creative Ways
to Enrich Your Life*
by Dirk Mathison
224 pages $9.95

The Butt Hello
*and other ways my cats
drive me crazy*
by Ted Meyer
96 pages $9.95

Café Nation
*Coffee Folklore, Magick,
and Divination*
by Sandra Mizumoto Posey
224 pages $9.95

Cats Around the World
by Ted Meyer
96 pages $9.95

**Discovering the History
of Your House**
and Your Neighborhood
by Betsy J. Green
288 pages $14.95

Dogme Uncut
*Lars von Trier, Thomas Vinterberg
and the Gang That Took on
Hollywood*
by Jack Stevenson
312 pages $16.95

Exploring Our Lives
*A Writing Handbook for
Senior Adults*
by Francis E. Kazemek
288 pages $14.95

Footsteps in the Fog
Alfred Hitchcock's San Francisco
by Jeff Kraft and
Aaron Leventhal
240 pages $24.95

**Free Stuff & Good Deals for
Folks over 50, 2nd Ed.**
by Linda Bowman
240 pages $12.95

**How to Find Your Family Roots
and Write Your Family History**
by William Latham and
Cindy Higgins
288 pages $14.95

How to Speak Shakespeare
by Cal Pritner and
Louis Colaianni
144 pages $16.95

**How to Win Lotteries,
Sweepstakes, and Contests in
the 21st Century**
by Steve "America's
Sweepstakes King" Ledoux
224 pages $14.95

**Jackson Pollock: Memories
Arrested in Space**
by Martin Gray
224 pages $14.95

James Dean Died Here
*The Locations of America's Pop
Culture Landmarks*
by Chris Epting
312 pages $16.95

The Keystone Kid
Tales of Early Hollywood
by Coy Watson, Jr.
312 pages $24.95

Letter Writing Made Easy!
*Featuring Sample Letters for
Hundreds of Common Occasions*
by Margaret McCarthy
224 pages $12.95

**Letter Writing Made Easy!
Volume 2**
*Featuring More Sample Letters for
Hundreds of Common Occasions*
by Margaret McCarthy
224 pages $12.95

Nancy Shavick's Tarot Universe
by Nancy Shavick
336 pages $15.95

Offbeat Food
*Adventures in an
Omnivorous World*
by Alan Ridenour
240 pages $19.95

Offbeat Marijuana
*The Life and Times of the
World's Grooviest Plant*
by Saul Rubin
240 pages $19.95

Offbeat Museums
*The Collections and Curators of
America's Most Unusual Museum*
by Saul Rubin
240 pages $19.95

Past Imperfect
*How Tracing Your Family Medica
History Can Save Your Life*
by Carol Daus
240 pages $12.95

A Prayer for Burma
by Kenneth Wong
216 pages $14.95

Quack!
*Tales of Medical Fraud from
the Museum of Questionable
Medical Devices*
by Bob McCoy
240 pages $19.95

Redneck Haiku
by Mary K. Witte
112 pages $9.95

**The Seven Sacred Rites
of Menarche**
*The Spiritual Journey of the
Adolescent Girl*
by Kristi Meisenbach Boylan
160 pages $11.95

**The Seven Sacred Rites
of Menopause**
*The Spiritual Journey to
the Wise-Woman Years*
by Kristi Meisenbach Boylan
144 pages $11.95

Silent Echoes
*Discovering Early Hollywood
Through the Films of Buster
Keaton*
by John Bengtson
240 pages $24.95

Tiki Road Trip
*A Guide to Tiki Culture in
North America*
by James Teitelbaum
288 pages $16.95

What's Buggin' You?
*Michael Bohdan's Guide to
Home Pest Control*
by Michael Bohdan
256 pages $12.95

Order Form 1-800-784-9553

	Quantity	Amount
Blues for Bird (epic poem about Charlie Parker) ($16.95)	_____	_____
The Book of Good Habits ($9.95)	_____	_____
The Butt Hello . . . and Other Ways My Cats Drive Me Crazy ($9.95)	_____	_____
Café Nation: Coffee Folklore, Magick and Divination ($9.95)	_____	_____
Cats Around the World ($9.95)	_____	_____
Discovering the History of Your House. . . ($14.95)	_____	_____
Dogme Uncut ($16.95)	_____	_____
Exploring Our Lives: A Writing Handbook for Senior Adults ($14.95)	_____	_____
Footsteps in the Fog: Alfred Hitchcock's San Francisco ($24.95)	_____	_____
Free Stuff & Good Deals for Folks over 50, 2nd Ed. ($12.95)	_____	_____
How to Find Your Family Roots . . . ($14.95)	_____	_____
How to Speak Shakespeare ($16.95)	_____	_____
How to Win Lotteries, Sweepstakes, and Contests . . . ($14.95)	_____	_____
Jackson Pollock: Memories Arrested in Space ($14.95)	_____	_____
James Dean Died Here: America's Pop Culture Landmarks ($16.95)	_____	_____
The Keystone Kid: Tales of Early Hollywood ($24.95)	_____	_____
Letter Writing Made Easy! ($12.95)	_____	_____
Letter Writing Made Easy! Volume 2 ($12.95)	_____	_____
Nancy Shavick's Tarot Universe ($15.95)	_____	_____
Offbeat Food ($19.95)	_____	_____
Offbeat Marijuana ($19.95)	_____	_____
Offbeat Museums ($19.95)	_____	_____
Past Imperfect: Tracing Your Family Medical History ($12.95)	_____	_____
A Prayer for Burma ($14.95)	_____	_____
Quack! Tales of Medical Fraud ($19.95)	_____	_____
Redneck Haiku ($9.95)	_____	_____
The Seven Sacred Rites of Menarche ($11.95)	_____	_____
The Seven Sacred Rites of Menopause ($11.95)	_____	_____
Silent Echoes: Early Hollywood Through Buster Keaton ($24.95)	_____	_____
Tiki Road Trip ($16.95)	_____	_____
What's Buggin' You?: A Guide to Home Pest Control ($12.95)	_____	_____

	Subtotal _____
Shipping & Handling: 1 book $3.00 Each additional book is $.50	CA residents add 8.25% sales tax _____ Shipping and Handling (see left) _____ TOTAL _____

Name _____

Address _____

City _____ State _____ Zip _____

❏ Visa ❏ MasterCard Card No.: _____

Exp. Date _____ Signature _____

❏ Enclosed is my check or money order payable to:

Santa Monica Press LLC
P.O. Box 1076
Santa Monica, CA 90406

www.santamonicapress.com 1-800-784-9553